IMAGES
of America

MOUNT BAKER

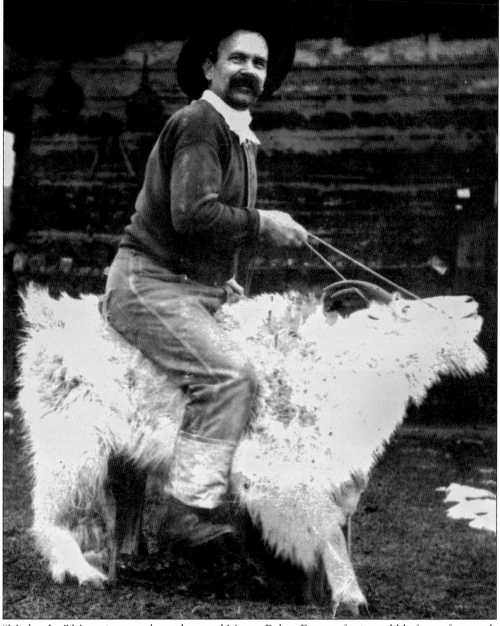

"Mighty Joe" Morovits was a legend around Mount Baker. Famous for incredible feats of strength and audacity, he once hauled a piece of mining machinery weighing 2,300 pounds from the town of Concrete to his cabin, a distance of 21 miles. When the task proved too difficult for his team of horses, he winched the machine from tree to tree. The effort took two years. (Courtesy of the Whatcom Museum.)

ON THE COVER: Members of the Mazamas Mountaineering Club pause on the Roman Wall, just below the summit plateau of Mount Baker. The Mazamas, formed in 1894, played an important role in the history of climbing in the Pacific Northwest, registering many first ascents. (Courtesy of Gordy Tweit.)

IMAGES
of America

MOUNT BAKER

To
BO
A Good Local History!

John D'Onofrio and Todd Warger

Cheers!

A
®

ARCADIA
PUBLISHING

Published by Arcadia Publishing
Charleston, South Carolina

Printed in the United States of America

Library of Congress Control Number: 2013943967

For all general information, please contact Arcadia Publishing:
Telephone 843-853-2070
Fax 843-853-0044
E-mail sales@arcadiapublishing.com
For customer service and orders:
Toll-Free 1-888-313-2665

Visit us on the Internet at www.arcadiapublishing.com

For Susan D'Onofrio and Renee Sherrer, embodying the
roles of muse, critic, and enlightened confidant

CONTENTS

ACKNOWLEDGMENTS

The authors want to thank the following individuals and institutions for their support in opening their private photographic collections and providing invaluable information that made this book possible: Jeff Jewell, Dawn Buckenmeyer, Laura Jacoby, Margaret Hellyer, David Tucker, John Scurlock, Michael Impero, Sarah Gabl, Gordy Tweit, John Miles, Gail Everett, Wes Gannaway, Sherman and Liz Ousdale, Steve Mayo, Gwyn Howat, Amy Trowbridge, Brett Baunton, Mel Monkelis, Whatcom Events, Deming Library, Whatcom Museum, Mount Baker Ski Area, the *Bellingham Herald*, and the National Archives Records Administration. Virtuoso photographic assistance was provided by Al Sanders and Jeff Daffron of Quicksilver Photo Labs, and vital technical aid was provided by Ethan D'Onofrio. Special thanks to Doug Banner, Randy and Claudia DeWees, Joe Jowdy, Barb Hansen, Rich Vanderwyst, Lance Ekhart, Denise Snyder, Marian D'Onofrio, and Christopher, somewhere in Uganda. We also wish to especially thank our editor at Arcadia Publishing, Rebecca Coffey, who kept us on track throughout the project.

INTRODUCTION

A dormant, but definitely *not* extinct volcano, Mount Baker dominates the landscape like few other peaks in the lower 48. At 10,781 feet, it is the third-highest mountain in the state of Washington and the second most heavily glaciated peak in the contiguous United States. For the native populations that lived in its shadow for millennia, it was sacred ground. For the miners and loggers who ventured ever closer to its mantle of ice and snow in their quest for gold and timber, it represented the mother lode; untapped riches for the taking. For the first climbers seeking its elusive, windswept summit, it was an opportunity for glory and triumph on a grand scale. For the businessmen of the 19th century, it was a blank canvas on which they hoped to paint a picture of prosperity and wealth. Mount Baker has always been more than its epic geography. Mount Baker is a state of mind.

The land around the mountain was paradise for the original inhabitants. The Lummi, Nooksack, Samish, Skagit, and Semiahmoo tribes enjoyed a wealth of natural resources provided by land and sea. They learned the mountain's secrets and built complex, richly nuanced cultures that celebrated the natural world and their place in it, finding a balance that nourished their physical and spiritual needs. They were inspired to create elaborate mythologies and beautiful artifacts that honored the mountain, forests, rivers, and sea.

Beginning with the Spanish explorer Manuel Quimper in 1790, Europeans entered the scene. Capt. George Vancouver arrived two years later and bestowed the name upon the mountain by which it is known today. Thus began an era of exploration and colonization that slowly penetrated the dense forests that surrounded the mountain. This advance was slow but relentless. Gradually, newcomers established homesteads on the wild, big-hearted rivers, built villages beneath the towering trees, and began to tentatively venture higher and higher, reaching for heights both real and metaphorical.

As the population around Bellingham Bay grew, industries sprang up. Mining, fisheries, timber—each had their day in the sun, and each brought both prosperity and heartbreak. Beginning in the 1890s, the Mount Baker Gold Rush lured countless rough-and-ready prospectors, eager to strike it rich in the gold fields north of the mountain. Businesses created to supply these men with equipment and provisions sprang up overnight, giving birth to new towns around the mountain. The miners' lives were almost unbelievably hard and, for most, unrewarded by the elusive big strike. But the trails that they gouged out of the wilderness would become wagon roads and, eventually, highways.

The loggers who made their lives among the great cedars and firs also suffered almost unthinkable deprivations, and the dangers they faced on a daily basis maimed and killed with shocking regularity. As their efforts became more and more mechanized through the introduction of the railroads, the steam donkey, and the chainsaw, the loggers' reach was extended. Inevitably, of course, the resource they sought diminished commensurately. In less than 100 years, the virgin forests were gone.

Adventure-seekers arrived at the mountain with dreams of a different kind. They were drawn by the chance to stand where none had stood before, to see the world from high and lonely places, to breathe the rarified air of terra incognita. Their efforts were also defined by struggle, danger, and adversity. Many sought the prize of conquest, but few attained it. More than a few died in the pursuit. Edmund T. Coleman was the first to reach the summit of Mount Baker when he surmounted the Roman Wall on August 17, 1868. Coleman had the right stuff. His first two attempts had ended in failure, but he learned from his mistakes and was rewarded with the euphoria of a dream fulfilled.

As the 19th century was winding down, the territory that would become Washington State was booming. From 1879 to 1889, its population grew by 365 percent. In the waning years of the century, two events of great portent occurred. On November 11, 1889, Washington was admitted into the Union as the 42nd state, and on March 2, 1899, Mount Rainier became the United State's fifth national park. Together, these two events set the stage for a form of commerce as yet unknown in the new state: tourism.

To capitalize on this new phenomenon, the Mount Baker Marathon was conceived to draw attention to the region. It was one of the most audacious schemes of its kind ever devised. The year was 1911, and Arthur J. Craven, the president of the Mount Baker Club, had dreams of riches and visions of national prominence that might translate into his favorite music: the ringing of cash registers. Much like the story of Mount Baker itself, it was a story of greed and triumph, heroism and near-disaster.

As a publicity stunt designed to further the establishment of a national park at Mount Baker to compete with Mount Rainier, the marathon was a failure. But as a symbol of the civic determination and never-say-die attitude of the community, its dramatic impact cannot be denied.

The marathon lasted for three years before it was mercifully stopped. At the end of the day, there was no Mount Baker National Park. But out of the scandal and near-disaster of the marathon, a beloved Northwest tradition would emerge. The annual Ski to Sea Race, held each year on Memorial Day weekend, is its direct descendant. This contemporary relay race has become an enduring community celebration and attracts participants from around the globe.

That audience was also what drove the Hollywood film industry to discover Mount Baker in the 1920s. Jack London's stories had ignited a demand for adventure tales set in the far north. In the eyes of film producers, Mount Baker looked very much like Alaska or the Yukon Territories. The production companies arrived at the mountain with movie stars and folding money, and, for a while, the good times rolled. Clark Gable and Loretta Young played in the snow of Heather Meadows. Locals were all too happy to be extras and enjoy the unique pleasures of seeing themselves on the silver screen of the Mount Baker Theatre.

The Mount Baker Lodge, constructed at Heather Meadows, opened for business in 1927. The realization of long-formulated dreams of putting Mount Baker "on the map," the lodge was a smashing success, attracting the elite of the day to the mountain's slopes. The lodge, a monument to elegance and rustic grace, immediately became a magnet, drawing crowds and generating an impressive cash flow. The dream literally went up in smoke in 1931 when a fire broke out in the early morning hours of August 5, reducing the iconic structure to steaming rubble.

Out of these ashes rose the Mount Baker Ski Area. A touch-and-go operation for years, the ski area hung on and gradually became an enduring success story. One of the first ski areas to embrace the upstart sport of snowboarding, it has become a beloved and storied destination for winter sports enthusiasts, capitalizing on its reputation as a down-home, unpretentious, off-the-grid resort.

In the all-too-brief summers that the mountain enjoys, another breed of adventurer populates the slopes. Climbers and hikers arrive each year in ever-increasing numbers, seeking the kind of pristine mountain experience that has all but vanished in the United States of America. They come to walk for days on end among scenes of otherworldly beauty: tender alpine meadows adorned with trembling avalanche lilies and sparkling lupine radiating beneath fangs of blue ice and black rock—a union of the impossibly delicate and the unutterably harsh. Exploration of

these resplendent highlands invariably includes a discovery of the depths of one's soul, a balm for these over-busy times.

The history of Mount Baker is the history of our evolution, our dreams, and our aspirations. Dreams of money, sure, but also dreams of connecting to our origins and preserving and celebrating the primeval beauty of the Pacific Northwest. Like the natives who honored their creator, we find opportunities to elevate ourselves—in every sense of the word. The mountain often plays hard-to-get in the swirling clouds that define the Pacific Northwest, unseen for weeks at a time. But, like our aspirations, it is there to be climbed.

This visual history of Mount Baker is made possible by a trio of brilliant photographers that spent their lives capturing the beauty of the landscapes and the diversity of man's interaction with it. Darius Kinsey bought his first camera and started taking photographs around Mount Baker in 1890. His images tell the larger-than-life story of the timber industry at the turn of the century and beyond. His wife, Tabitha, did the darkroom work. Together, they were a great team.

Galen Biery was a native son, born in Bellingham in 1910. Combining his skill as a photographer with a passion for preservation, he spent 50 years collecting, copying, and preserving thousands of historical photographs which otherwise would have been lost forever. His hand-tinted "magic lantern" slide shows were the stuff of local legend and, to this day, possess a nostalgic beauty.

Bert Huntoon was Whatcom County's Renaissance man. In addition to being the driving force behind the establishment of the Mount Baker Highway, the Mount Baker Lodge, Sehome Park, and Chuckanut Drive, he was a dedicated photographer whose images captured his deep connection to the Mount Baker region.

We owe these three men a great debt. Without their vision, so much would have been lost. Each of them seemed to have a great sensitivity to the passing of time and the ephemeral nature of our ongoing dance with the natural world.

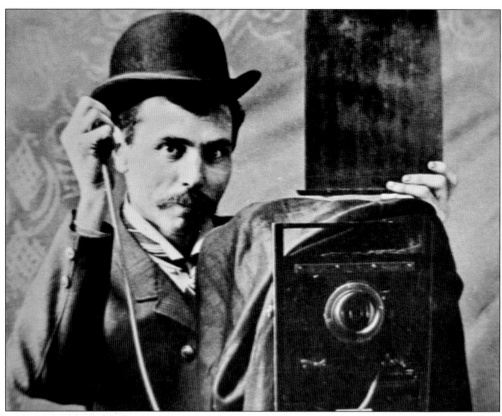

Darius Kinsey arrived in the Pacific Northwest in 1889 and spent the next 50 years documenting life in the logging camps around Mount Baker. Kinsey's images capture the Bunyan-esque scale of the great old-growth forests and serve as witness to the grit and determination of the men who risked life and limb to cut them down. (Courtesy of the Galen Biery Collection.)

Bert Huntoon was a tireless advocate for the promotion of the mountain as a recreational and aesthetic asset to the area, playing key roles in the construction of the Mount Baker Highway and Mount Baker Lodge. Among his many interests, he pursued photography with the unreserved passion of a man in love with the mountain. (Courtesy of the Galen Biery Collection.)

One

Discovery, Exploration, and Conquest

The "discovery" of Mount Baker by Europeans is attributed to Manuel Quimper, leading a charting expedition of the Strait of Juan De Fuca by the Spanish Navy in 1790. Of course, by then, the native peoples had been living in the shadow of the mountain for at least 10,000 years. For the members of the Lummi Nation, the mountain was known as *Qwú'm Kwlshén*; to the Nooksack Tribe, it was *Kw'eq Smaenit* or *Kwelshán*. Quimper's pilot, Gonzalo Lopez de Haro, labeled the mountain La Gran Montena del Carmelo on his chart. Capt. George Vancouver entered the strait two years later with his ships HMS *Discovery* and HMS *Chatham* and "rediscovered" the mountain "towering above the clouds." Vancouver, unaware of the name bestowed upon it by Haro, named it Mount Baker after his third lieutenant, Joseph Baker. In 1846, after much territorial wrangling between the United States and Great Britain, the border with Canada was established along the 49th parallel, and Mount Baker became part of the United States. In 1852, Henry Roeder and Russell Peabody arrived in a dugout canoe on the shores of Bellingham Bay, the first white settlers in Whatcom County. Fort Bellingham was established in 1856, and the Fraser River Gold Rush of 1858 fueled settlement on the land west of the mountain. Mount Baker itself, however, remained terra incognita.

In 1868, after two failed attempts, Edmund Thomas Coleman arrived in Bellingham to mount what would become the first expedition to reach the top of the mountain. On August 17, 1868, Coleman and three companions reached the summit, via what is now known as the Coleman Glacier. "No word was spoken," Thomas Stratton, a member of the climbing party, reported. "We stood with clasped hands, contemplating the majestic grandeur of the scene."

Men would not stand on the summit again for 23 years.

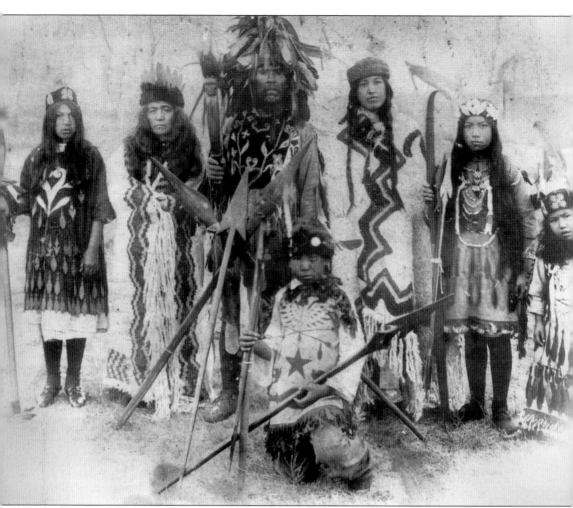

The native peoples of the Mount Baker area included both the Lummi Nation and Nooksack Tribe. Both groups had inhabited the lands to the west of Mount Baker for more than 10,000 years. By the time Capt. George Vancouver arrived on the scene, the Lummis lived on the edge of the Salish Sea, around the mouth of the Nooksack River. Historically, they had lived throughout the San Juan Islands. Their culture was based on fishing, gathering shellfish, and hunting sea mammals, and they produced amazing objects of great beauty, including cedar baskets, blankets, and sleek, seagoing canoes. The Nooksacks lived inland along the river that bears their name in 25 distinct sites that were home to their winter villages. In addition to fishing, they hunted elk, mountain goat, and deer. Salmon were of great importance to both groups. (Courtesy of the Whatcom Museum.)

Capt. George Vancouver named Mount Baker for his third lieutenant, Joseph Baker, who first saw the mountain on March 16, 1792, from the HMS *Discovery*. The ship was exploring near Dungeness Bay in the Strait of Juan De Fuca when the mountain came into view, "a very conspicuous object" according to Vancouver. (Painting by Steve Mayo; courtesy of Steve Mayo.)

This woodcut, dating to the late 1800s, shows the mountain as seen from Fairhaven, on the shores of Bellingham Bay. In the 1850s, coal mines at Sehome (now part of Bellingham) fueled modest population growth in the area, but the area around Mount Baker was still largely unexplored. (Courtesy of the Whatcom Museum.)

German immigrant Henry Roeder arrived in Whatcom County on December 14, 1852, and started the first sawmill in the region on Whatcom Creek the following year. He was instrumental in the economic development of the area and active in local politics. Roeder died in 1902. (Courtesy of the Galen Biery Collection.)

This painting by James Everett Stuart captures a fanciful view of Mount Baker as seen from near Port Townsend on the Olympic Peninsula. The native people that populated the northern Puget Sound region regarded the mountain with reverence and awe. Although they hunted mountain goats on its slopes, there is no indication that they ever ventured onto the glacial ice that surrounded the summit. (Courtesy of the Whatcom Museum.)

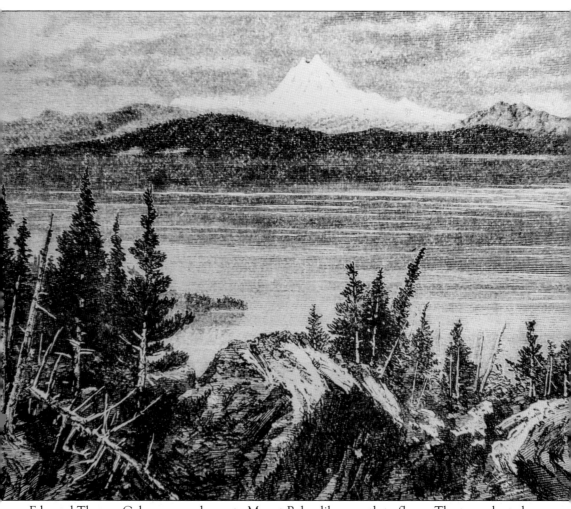

Edmund Thomas Coleman was drawn to Mount Baker like a moth to flame. The transplanted Englishman arrived in Victoria, British Columbia, in 1862. A botanist and artist, he was also an avid mountaineer with extensive climbing experience in the Alps. Upon his arrival on Vancouver Island, Coleman determined to scale the as-yet-unclimbed, snow-covered dome of Mount Baker, visible in the east across the Strait of Georgia in this rendering by Coleman. In July 1866, he sailed via steamship to Port Townsend on the Olympic Peninsula, and from there, crossed Puget Sound in a native canoe, arriving at the Skagit River. He followed the river upstream to its confluence with the Baker River. Convinced that this watercourse would bring him to the mountain, he attempted to procure the services of Indian guides but was dismayed when the natives refused to guide his party. They furthermore refused him passage up the river. (Courtesy of the Galen Biery Collection.)

After he was turned back by the natives, Coleman tried again two days later. He was accompanied by Scotsman and fellow botanist John Bennett. This time, the men started in Bellingham, where Coleman sought information from the settlers there. (Courtesy of the Galen Biery Collection.)

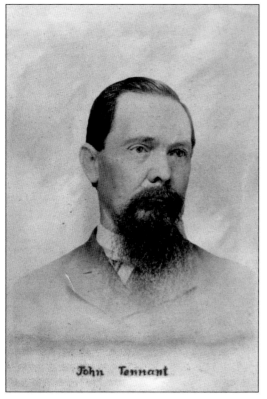

John Tennant

In Bellingham, Edward Eldridge advised Coleman that the Nooksack River offered a better approach to the mountain. Eldridge agreed to join the expedition and help facilitate passage upriver with members of the Lummi and Nooksack tribes. Along the way, Coleman recruited a fourth member of the party. John Tennant (shown here), also a botanist, had a homestead near the river. (Courtesy of the Galen Biery Collection.)

The group struggled up the Nooksack River and Glacier Creek, which they followed to what is now known as the Coleman Glacier. They ascended until they were stopped by "a wall of ice" a few hundred feet below the summit plateau. Coleman's second attempt had ended with the frustration of finding his goal so tantalizingly close, yet unreachable. This etching is by Edmund Coleman. (Courtesy of the Galen Biery Collection.)

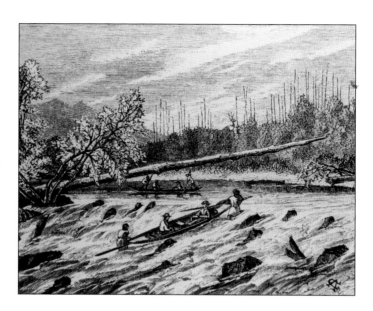

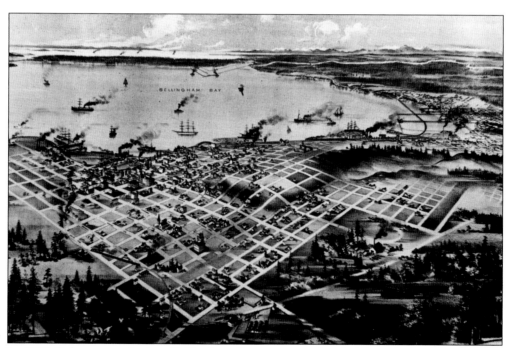

In 1868, Coleman was back at Bellingham Bay, transported with fellow climber David Ogilvy through the San Juan Islands by Indian canoe from Victoria. At Eldridge's opulent waterfront home, they were joined by Thomas Stratton, a customs inspector from Port Townsend that Coleman had invited along on this third attempt at the summit. (Courtesy of the Galen Biery Collection.)

On August 7, the party started up the Nooksack, aided by some of the same members of the Nooksack tribe that had helped Coleman in 1866. Again, he stopped at John Tennant's homestead to recruit him. Again, he was successful. This time, the group turned up the *Nuxtig'um*, or Middle Fork of the river, where they were forced to portage three times. Part of the trip is seen in this Edmund Coleman etching. (Courtesy of the Galen Biery Collection.)

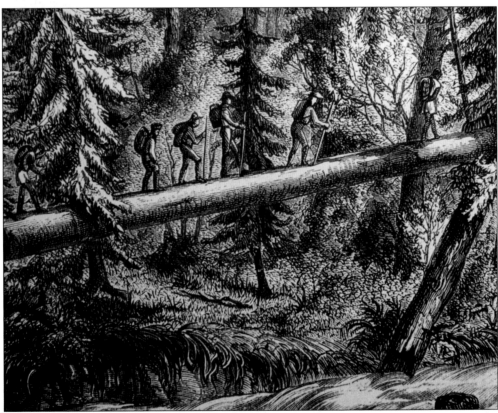

By August 11, the canoes had reached the far limits of navigability on the Middle Fork. The men shouldered heavy packs and set out on foot through the almost impenetrable brush along the riverbank, as depicted in this Edmund Coleman etching. After three exhausting days in the dense, fog-enveloped forest, they caught a glimpse of glacial ice below them. They camped here, calling the spot Camp Hope. (Courtesy of the Galen Biery Collection.)

The men reached an elevation of about 6,000 feet. The clouds finally lifted, revealing two spectacular black peaks rising from the ice. Coleman named them Colfax and Lincoln Peaks. But most heartening to the men was the sight of the gleaming snow dome of Mount Baker, seemingly close at hand. (Courtesy of the Galen Biery Collection.)

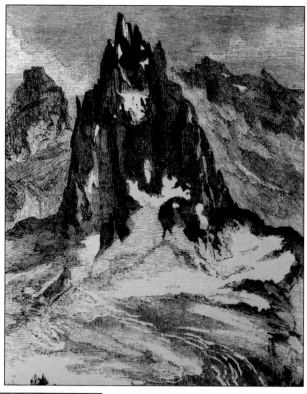

On August 17, at 5:30 a.m., the party set off on its final push to the summit. After ascending the glacier, Coleman once again arrived at the wall of ice just below the summit that had thwarted him two years previously. This feature, depicted here by Coleman, is today known as the Roman Wall. (Courtesy of the Galen Biery Collection.)

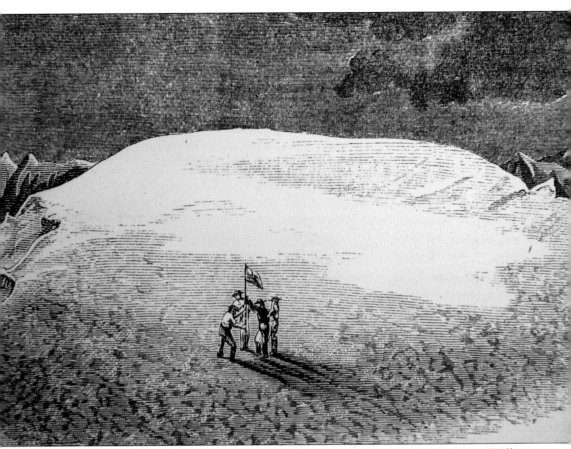

This time, Coleman and his companions refused to let the steepness of the Roman Wall stop them, despite Coleman's assessment that "a single false step would have been fatal." By 4:00 p.m., Coleman, Tennant, Stratton, and Ogilvy found themselves atop Mount Baker. "The scene was grand in the nakedness of its desolation," Coleman reported. "We felt at Heaven's gate and in the immediate presence of the Almighty." They sang religious and patriotic songs, passed a flask of brandy among them, and planted an American flag in the snow (seen here in a Coleman etching). Coleman named the highest point Grant Peak, after Ulysses S. Grant, and bestowed the name of Sherman Peak on the lower crest. The persistence of Edmund Coleman had won the day—and the summit. (Courtesy of the Galen Biery Collection.)

In June 1884, five prospectors ventured up the South Fork of the Nooksack River in search of gold. After exploring the Three Sisters Range, the group found themselves on the southern flanks of Mount Baker, where they split up. Two men went off to hunt mountain goats, which were prevalent in this area, while Victor Lowe (shown here) and two companions decided to attempt to climb the mountain, which had not been summited since Coleman's first ascent in 1868. Lowe and companion L.L. Bales ascended a large glacier on the southeast ridge above the Baker River. They reached the summit of Sherman Peak, one-half mile east of (and 700 feet below) Grant Peak, the true summit. (Courtesy of the Galen Biery Collection.)

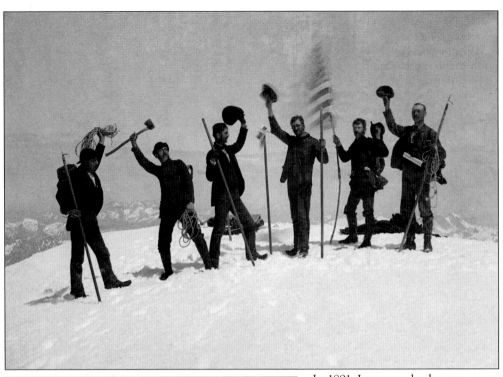

In 1891, Lowe was back to try again with seven companions, and this time, the party reached the true summit. It was the second complete ascent of the mountain. The route took them up Heliotrope Ridge and the Coleman Glacier, a popular route to this day. This was the first photograph ever taken on the summit of Mount Baker. (Courtesy of John C. Miles.)

Sue Nevin was the first woman to reach the summit. She was a member of the La Conner Party, the first to ascend from Baker Lake via the Boulder Ridge/Boulder Glacier route in 1891. Nevin impressed her companions, who described her as a "brave Iowa girl." (Courtesy of John C. Miles.)

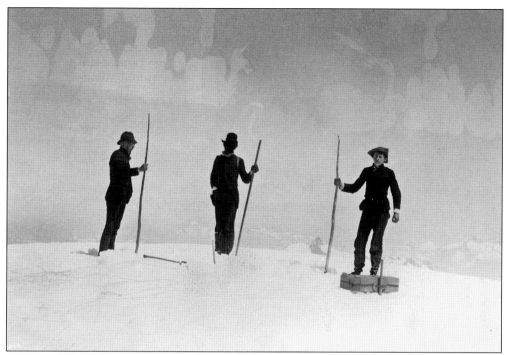

By 1892, climbing the mountain had become almost routine. Here, three climbers pose on Grant Peak for the obligatory summit photograph. A new era of sport climbing had begun on Mount Baker, a period that mountain historian Charles Finley Easton described as "an epidemic of mountaineering." (Courtesy of John C. Miles.)

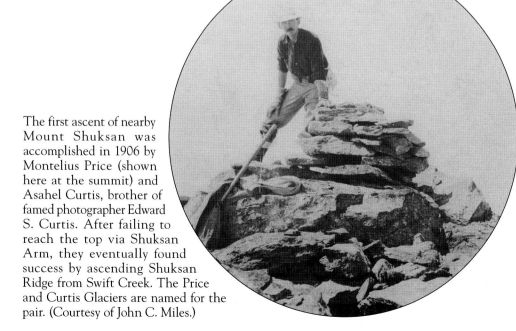

The first ascent of nearby Mount Shuksan was accomplished in 1906 by Montelius Price (shown here at the summit) and Asahel Curtis, brother of famed photographer Edward S. Curtis. After failing to reach the top via Shuksan Arm, they eventually found success by ascending Shuksan Ridge from Swift Creek. The Price and Curtis Glaciers are named for the pair. (Courtesy of John C. Miles.)

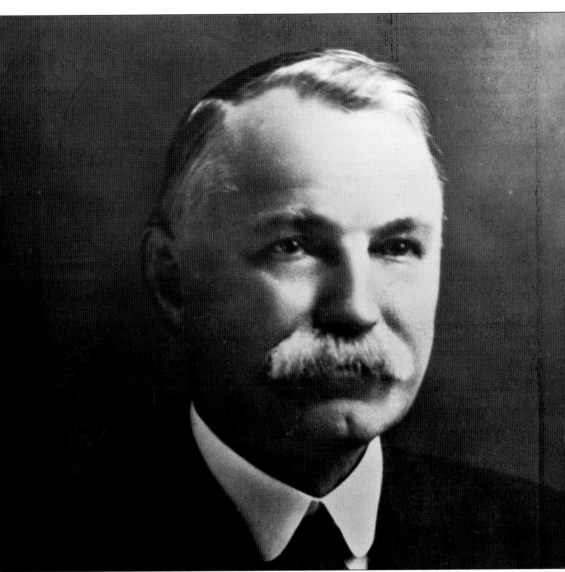

Charles Finley Easton was an avid mountaineer and photographer. A member of the Mazamas, a mountaineering club formed in 1894, he joined the group's unsuccessful attempt on the summit in 1906. He assembled a party two years later to climb the west side of the mountain from Glacier Creek. As they approached the summit, a storm blew in, and he and his three companions dug a snow cave just below the crest, where they spent the night. After reaching the summit the next morning, Easton elected to descend the eastern slope, and the party was forced to bivouac in a crevasse. The next day, they descended via the Boulder Cleaver, thus completing the first traverse of Mount Baker's summit. When the Mount Baker club was formed in 1911, Easton became the group's historian. The Easton Glacier, a popular climbing route today, is named for him. (Courtesy of the Galen Biery Collection.)

In 1886, Banning Austin undertook a journey to explore the Mount Baker area with the hope of constructing a road across the mountains. In the course of his travels, he discovered a low pass between Mount Baker and Mount Shuksan, now known as Austin Pass. In this photograph, Austin (left) watches his father skin a bear. (Courtesy of the Galen Biery Collection.)

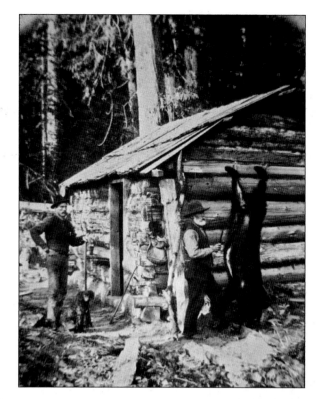

Everett B. Deming, the president of Pacific American Fisheries in Bellingham, became a key figure in developing Mount Baker as a resort. The first president of the Mount Baker Development Corporation, Deming was skeptical about the virtues of development on the mountain until a trip to Austin Pass convinced him to support construction of the Mount Baker Highway and Lodge. (Courtesy of the Galen Biery Collection.)

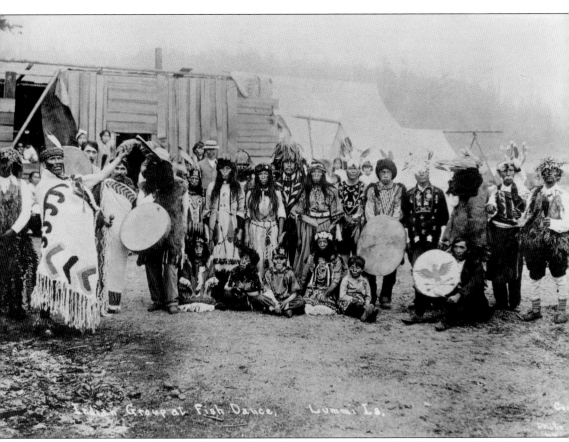

Indian Group at Fish Dance, Lummi Is.

By 1915, when this photograph was taken, things were changing for the original inhabitants of the area. The 1855 Treaty of Point Elliot had mandated the relinquishing of much of the tribe's homelands in exchange for designated reservations and recognition of hunting, fishing, and gathering rights. However, the Nooksack Tribe was not granted a reservation, instead instructed to relocate onto the newly created Lummi Reservation, an offer that they declined. After attempts to forcibly move the tribe in 1873 and 1874 failed, tribal members were able to gain ownership of portions of their ancestral lands by filing homestead claims. In the years to come, the Treaty of Point Elliot would prove disastrous for the native populations. In addition to the Lummis and Nooksacks, the other tribes in the Mount Baker area—the Semiahmoo, Samish, and Skagit—were in decline. The promises of Point Elliot proved to be empty indeed. (Courtesy of the Whatcom Museum.)

Two

The Mount Baker Gold Rush

The quest for mineral riches around Mount Baker dates to the earliest days of white settlement in the area in the 1850s. The Mount Baker Mining District was established in 1898, following the discovery of gold at the Lone Jack Mine, near Twin Lakes, in 1897. This strike ignited the Mount Baker Gold Rush and transformed the gateway towns west of the mountain into jumping-off places for hopeful miners. The sale of provisions and supplies to these eager men became big business and helped establish these emerging communities. Between 1890 and 1937, more than 5,000 claims were filed, and the high country was home to a steady stream of starry-eyed prospectors equipped with picks and dreams of riches. In these early years, accessing the slopes around Mount Baker was a monumental effort in itself. No bridges spanned the rivers, and beyond Loop's Ranch near Maple Falls, supplies had to be hauled by mules, horses, and men. East of Loop's Ranch, a remote homestead was established in 1888 by Chester C. Cornell after the discovery of a seam of coal nearby. In 1909, this outpost was renamed Glacier. By 1910, the fledgling town boasted two hotels.

Meanwhile, at the present site of the Mount Baker Highway Maintenance Facility at the intersection of the Mount Baker Highway and Twin Lakes Road, the short-lived town of Shuksan sprang up to cater to the miners. The Boundary Red Gold Mine was established near the Canadian Border on the high ramparts of Red Mountain (Larrabee) in 1898. The difficulty of working at such high elevations in these unforgiving mountains was extreme. Avalanches routinely swept down on the operations, and the logistics involved in extracting the precious metals and transporting them back to civilization were formidable. These mines, nearly all forgotten now, included the Gargett/Gold Run, the Grand Excelsior, Gold Basin, and the Silver Tip. For some, the dreams of riches came true, but for most, it was a dream denied. By 1937, only the most hard-core prospectors remained in the mountains.

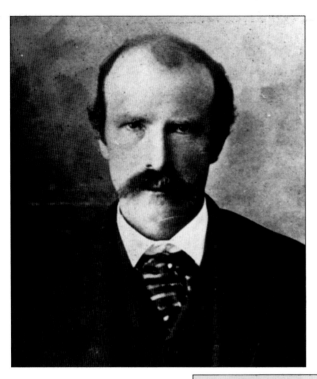

In 1897, Jack Post (shown here) and two fellow prospectors, Russ Lambert and Luman Van Valkenburg, discovered "color" in a mountain stream on a shoulder of Bear Mountain, which led to the discovery of what became known as the Lone Jack vein, a rich quartz deposit that contained gold. (Courtesy of Michael G. Impero.)

The Mount Baker Gold Rush fueled a wide variety of economic activity throughout the region. Businesses sprang up overnight to capitalize on opportunities to sell supplies and provisions to the miners who flooded into the area during "the dawn of the stampede." (Courtesy of Michael G. Impero.)

MASS-MEETING
TO-NIGHT
Monday, Sept. 20th, 8:00 P. M.
AT THE CITY HALL

To devise means to make BELLINGHAM BAY the only base of supplies for

WHATCOM GOLD MINES

Reach the Silicia Creek Mines from Bellingham Bay only.

BUSINESS MEN UNITE!

Now is the time to strike for the trade in the dawn of the stampede.

EVERY BUSINESS MAN COME!

Whatcom Board Trade and Citizens.

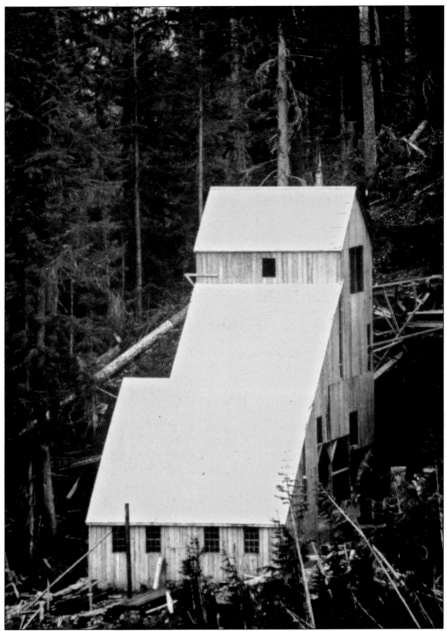

The Mount Baker Gold Rush began at the Lone Jack Mine, located near Twin Lakes. The Lone Jack was the most famous mine in the region, producing a half-million dollars' worth of gold between 1898 and 1907 and providing the impetus for the development of roads and trails in the upper Nooksack drainage. The three original owners sold the mine to a Portland, Oregon, mining company that took on the monumental task of creating facilities at the remote site. The processing plant and housing for the workers was situated in a stand of trees above Silesia Creek. This location in the trees protected the structures from the regular avalanches that rumbled down the slopes of Bear Mountain. Such avalanches would eventually destroy every other structure built on Bear Mountain, including the upper buildings of the Lone Jack located 4,000 feet higher up the mountain at an elevation of 5,600 feet. (Courtesy of Michael G. Impero.)

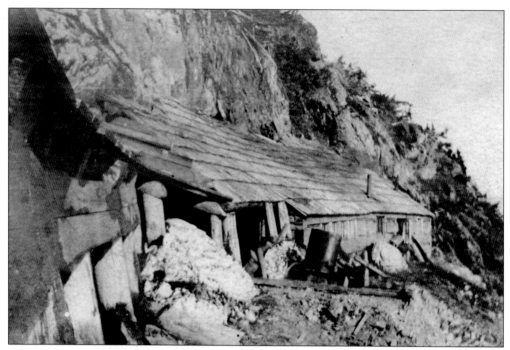

The upper area of the mine, where the tram works were situated, was located in this facility. The mine was intended to be a year-round operation, but, during the first winter, an avalanche swept down and destroyed the building. Luckily, the workers were in the mine at the time and only the cook was in the building, preparing a meal. He escaped without serious injury. (Courtesy of Michael G. Impero.)

Jack Post (left), with his trusty six-shooter, and prospector Amos Zimmer are seen camping at Twin Lakes. Post roamed the mountains around Mount Baker, looking for adventure and gold. He named nearby Winchester Mountain after another of his guns, a Winchester .30-30. (Courtesy of Michael G. Impero.)

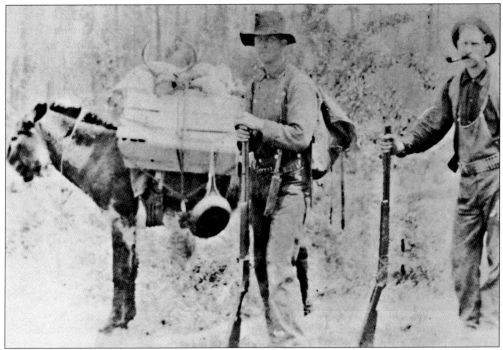

Miners and their pack mules are en route to the goldfields in the Ruth Creek area just south of the Canadian border in 1898. Fred Griffin is on the right. After gold was discovered in 1897, hopeful miners flooded into the Mount Baker area. Most left empty-handed. (Courtesy of the Deming Library.)

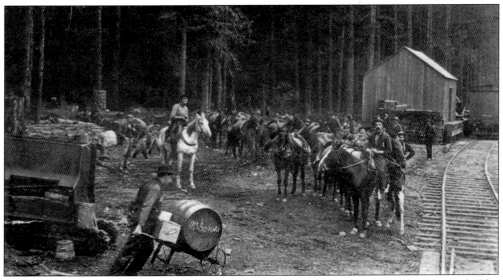

At the Maple Falls train station, a pack train is loaded with supplies headed to the Lone Jack. The transportation of supplies created formidable difficulties for the owners of the mines throughout the history of the Mount Baker Mining District. (Courtesy of Wes Gannaway.)

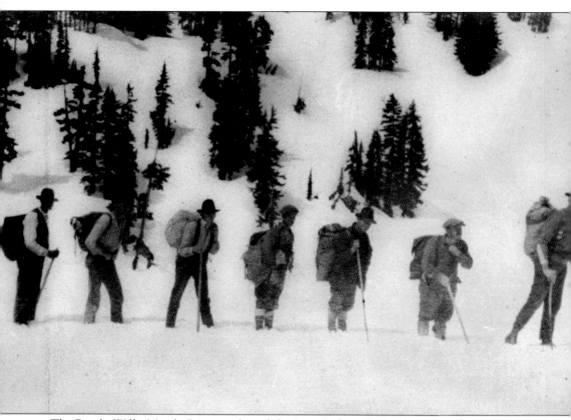

The Brooks-Willis Metals Company leased the Lone Jack in 1917 and purchased it in 1920. Carl Willis had big plans for the operation. He brought in a large crew to build a new ore-processing mill, sawmill, bunkhouse, and power plant in the middle of an avalanche chute, believing that a few old-growth fir trees growing upslope would protect the structures from winter's wrath. This decision would have disastrous consequences. The new mill building was completed by Thanksgiving of 1922, when the mine shut down for the winter. A few months later, Willis dispatched a party of men, pictured here, to trek through the deep snow to the mine to check on conditions. They returned with bad news. The mill had taken a direct hit from an avalanche, and much of it had been destroyed. (Courtesy of Michael G. Impero.)

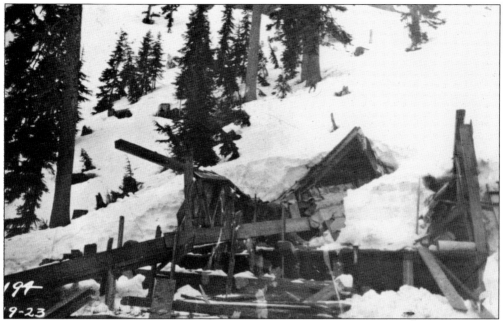

The assay office at the Lone Jack is pictured here as it was discovered by the midwinter inspection party in 1923. Carl Willis's ambitious plans to expand and upgrade the mine's operations were soundly trumped by Mother Nature. It was yet another example of the extreme difficulty of conducting operations in the rugged high country of the North Cascades. (Courtesy of Michael G. Impero.)

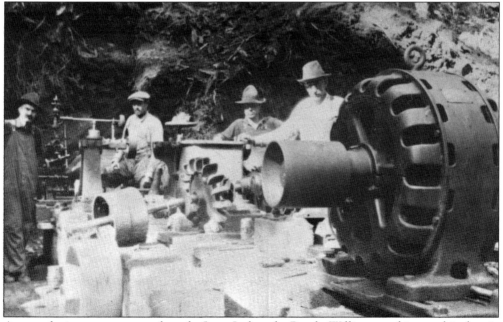

Among the improvements made at the Lone Jack under Brooks-Willis ownership was this electric water-power plant, built on a hill 100 feet above Silesia Creek. Water was diverted from Garrison and Whist Creeks into a wood flume and then dropped 500 feet to the Pelton Wheel. The power plant supplied electricity to the mill and assay office. (Courtesy of Michael G. Impero.)

In 1925, after many of the buildings at the Lone Jack were severely damaged by avalanches, Harry Bullene was hired by the owners at the time, the Brooks family, to repair the damaged buildings. When Josephine Brooks died in the 1940s, Bullene found himself the new owner. He leased the mine to Robert J. Cole in the early 1950s. (Courtesy of Michael G. Impero.)

In 1964, a group of Boy Scouts from Bellingham discovered this cache of dynamite in the Lulu shaft of the Lone Jack. They reported their find to the US Forest Service station in Glacier, which enlisted the explosives team from the Whidbey Naval Air Station to detonate the dynamite, an event that attracted curious spectators from around Whatcom County. (Courtesy of Michael G. Impero.)

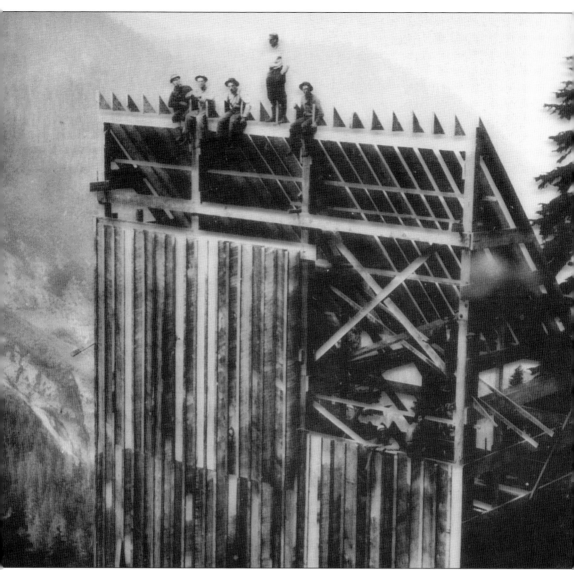

Gold was discovered on the slopes of Red Mountain (now known as Mount Larrabee) by C.W. Both in 1897. The Red Mountain Gold Company was established in 1902, and the Boundary Red Mine quickly became one of the most productive gold mines in the Mount Baker area. The ore-processing building, shown here, was where the gold was separated from the crushed ore. The mine was located within a half-mile of the Canadian border, and gold was transported through Canada in the form of gold bricks. In 1915, George Wingfield of Goldfield Consolidated Mining Company leased the mine and greatly expanded the operations, installing a water-driven power plant on nearby Silesia Creek and expanding capacity to 60 tons per day. In its heyday, between 1913 and 1946, the Boundary Red produced more than $1 million in gold. (Courtesy of Michael G. Impero.)

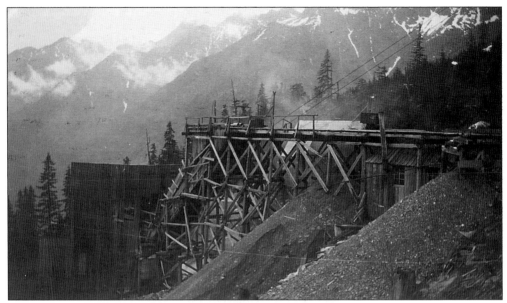

The processing building at the Boundary Red Mine received ore from both an overhead tramway and an ore cart. Working conditions at the mine were challenging. In winter, avalanches were a common occurrence, and in the spring, snowmelt created flooding. The dangerous work and profound isolation combined to create extremely high turnover among the mine workers. (Courtesy of Michael G. Impero.)

Russ Lambert arrived in Whatcom County in 1890 and was elected mayor of the mining supply town of Sumas in 1895. In addition to politics, Lambert's abiding passion was prospecting. He was one of the founders of the Lone Jack. Lambert would disappear into the mountains for months at a time. (Courtesy of Michael G. Impero.)

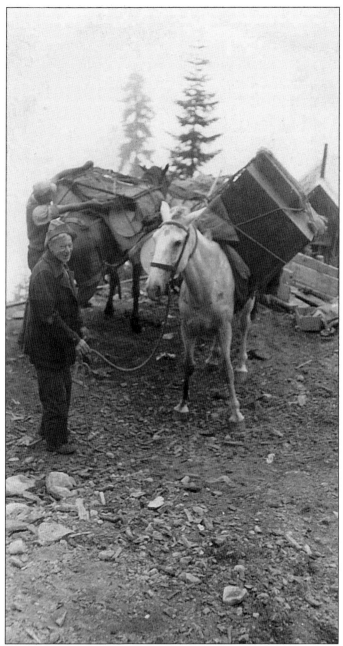

Ed Bell was a legendary packer who brought supplies into the Boundary Red Mine over rough trails that climbed high on the slopes of Red Mountain. Bell's wife, Louise, often accompanied him on these packing trips to bring supplies in and gold bricks out. His horse, Sheba, was renowned for carrying immense loads. Here, Sheba carries a 500-pound Monarch cook stove. Mine operators made a wager with Bell that Sheba could not make it all the way to the mine with the stove. Bell loaded a specially constructed tripod on a second horse and used it to suspend the stove off of Sheba's back at intervals to give the horse periodic rests. It took three days for Bell and Sheba to complete the trip, but they eventually made it to the Boundary Red. Bell collected on the bet. (Courtesy of Michael G. Impero.)

The Gold Run Mine was established in 1911 by a group of prospectors from Sumas. It was soon thereafter purchased by the Gargett brothers, also from Sumas, and renamed the Gargett Mine. The brothers constructed a mining/recovery building, sawmill, and living quarters. Roy Gargett, the eldest brother, is pictured here. The mine was located on a precipitous shoulder of Red Mountain near High Pass. Conditions at the mine were harsh, with snow lingering for most of the year. The brothers lived in this lonely mountain aerie from early spring through October for 20 years. During that time, the mine produced no ore of any value, despite the brothers' tenaciousness. Supplies and machinery were hauled from the one-time mining outpost of Shuksan, five miles away and 4,000 feet below the Gargett. (Courtesy of Michael G. Impero.)

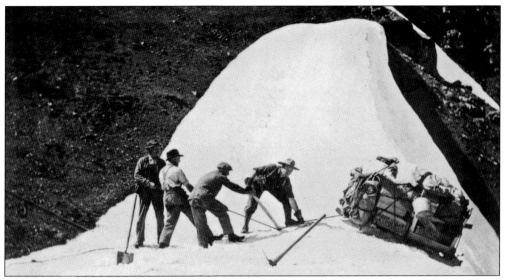

Transporting supplies to the Gargett Mine was a daunting task due to its inaccessibility and high elevation. Here, men haul a sled loaded with provisions and supplies over the precipitous crest of Gold Run Pass. Note the box labeled "Keep in a Cool Dry Place." (Courtesy of Michael G. Impero.)

Much of the country around Mount Baker was untrammeled wilderness at the beginning of the Mount Baker Gold Rush. This newspaper advertisement advised prospective miners to bring a gun with them for the purpose of procuring meat should they be venturing "above Loops' Inn." (Courtesy of Michael G. Impero.)

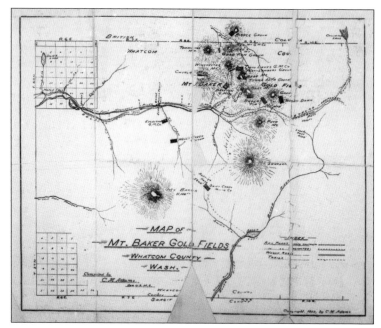

This map, drawn by C.M. Adams in 1902, shows the Mount Baker Gold Fields at their heyday. Much of the gold-mining activity was focused in the area around Winchester Mountain to the north of Mount Baker and just south of the international border. (Courtesy of Michael G. Impero.)

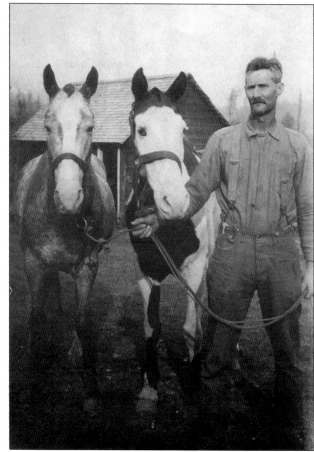

Charlie Bourn, a resident of Glacier, was an important figure in the development of mining interests around Mount Baker. With his packhorses Bob (left) and Pinto, Bourn transported much-needed supplies to the remote mining operations. (Courtesy of Michael G. Impero.)

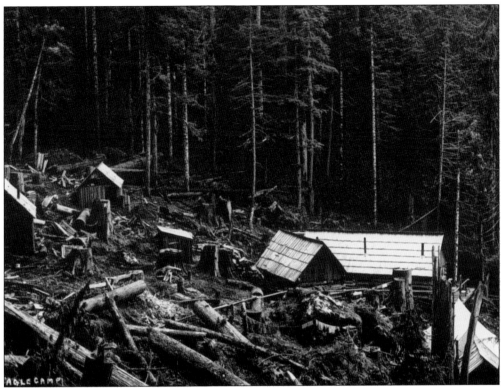

The American Eagle Mining Camp served as base for the small mining operations scattered throughout the area. The camp was located on the Wells Creek Trail, south of the North Fork of the Nooksack River. (Courtesy of Michael G. Impero.)

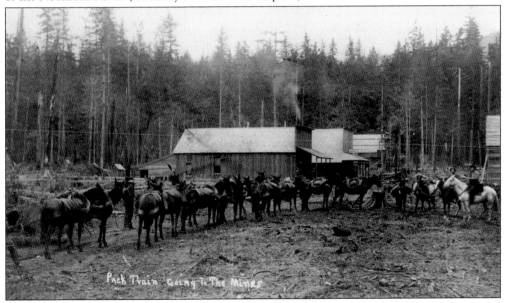

The town of Shuksan was established as a supply base for area miners after gold was discovered at the Lone Jack. It boasted cabins, a store, a livery stable, and a post office. The boomtown was short-lived; after just eight years, it had become a ghost town. (Courtesy of Michael G. Impero.)

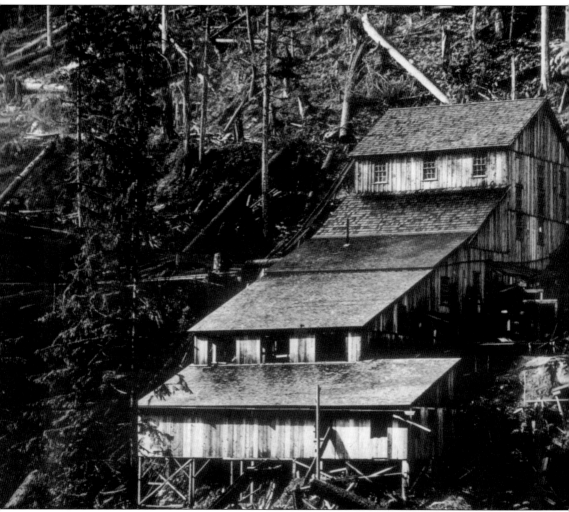

In 1900, W.H. Norton discovered gold beside the Nooksack River. The Great Excelsior Mine Company was formed in 1901, and a mill building was constructed in 1902. Thanks to the relatively low elevation (2,000 feet), the Grand Excelsior benefited from easier transportation of supplies and somewhat more benign weather. The first gold bricks taken from the mine arrived in Seattle in November 1902, prompting optimism about the mine's productivity. This optimism proved unfounded, however, and the mine failed to deliver on its early promise. In 1905, the Great Excelsior became the property of the President Group Mining Company, and Bellingham resident Hugh Eldridge became its president. Eldridge, born in 1860, was the son of Edward and Teresa Eldridge, two of the first white settlers on Bellingham Bay. In 1916, the mine ceased operations. By the time the Mount Baker Gold Rush was over, few had become rich, but the mining activity opened up the rugged country around Mount Baker by prompting the construction of towns, roads, and trails. (Courtesy of Michael G. Impero.)

Three

THE ERA OF SAWMILLS, STEAM DONKEYS, AND SKID ROADS

The Pacific Northwest of the 19th century was an uncrowded place. In the first census of the Washington Territory, taken in 1853, the population (not counting the remnants of the native tribes) was less than 4,000 people. Towns were few and far between. But there was no shortage of trees. The first settlers to Whatcom County encountered towering forests that started on the banks of the Salish Sea and continued unbroken high into the mountains. Henry Roeder opened the Whatcom Milling Company, the county's first sawmill, at Whatcom Creek in 1853. The completion of the Bellingham Bay and British Columbia Railway in 1891 was instrumental in creating cost-effective transportation of wood products from the interior of the county to the shores of Puget Sound. By 1893, several enormous old-growth logs harvested from Whatcom County were on their way to the World's Columbian Exposition in Chicago, where their remarkable size proved a sensation with awestruck Midwesterners, the myth of Paul Bunyan come to life. In 1897, Pres. Grover Cleveland created the Washington Forest Reserve, which included the area around Mount Baker. The term *preserve* did not imply preservation, however.

By the early years of the 20th century, scores of small logging companies and mills had sprung up like mushrooms after a spring rain, capitalizing on the expanding reach of the railroads. These mills maintained stretches of spur tracks. The largest of them, the Bloedel-Donovan Mill, had 140 miles of track! Replacing oxen and horses, the "steam donkey," a wood-burning machine with cables that moved logs, became omnipresent in the woods, and the harvest ratcheted up. In 1907, the world's largest shingle mill, Puget Sound Mills and Timber Company, was operating in Whatcom County. By 1925, the first logging trucks were rolling over county roads, and in the early 1940s, the introduction of the power saw again accelerated the cutting. By the end of that decade, the last of the virgin forests were gone, and all that remained of Whatcom County's old-growth forests were isolated stands of ancient giants, a remnant of what once was.

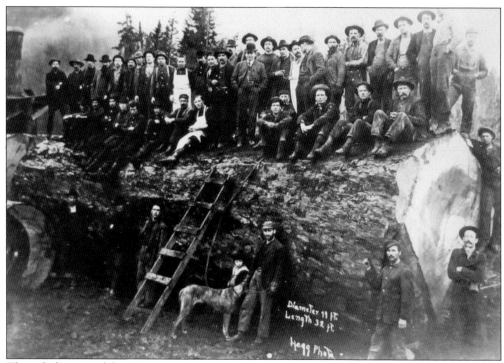

The inhabitants of the W.F. McKay Logging Camp pose with a giant fir log in 1892. The camp was located near present-day Wickersham, along the middle fork of the Nooksack River. Saturday nights often meant a trip to town, where hard-earned wages were spent on liquor, gambling, and women. (Courtesy of the Deming Library.)

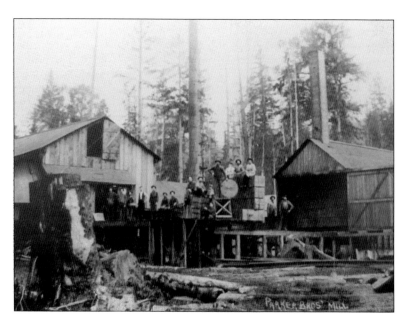

The Parker Brothers Mill operated in Deming during the waning years of the 19th century. This 1896 photograph shows millworkers in a rare moment of leisure. The mills of the era were busy churning out wood products, ranging from finished lumber to cedar shakes. (Courtesy of the Deming Library.)

Loggers stood on springboards—planks inserted into notches cut in the tree—to facilitate cutting above the buttress at the base of the tree. Axes were used to remove a wedge section of the tree. This cut would determine the direction that the tree would fall. (Courtesy of the Galen Biery Collection.)

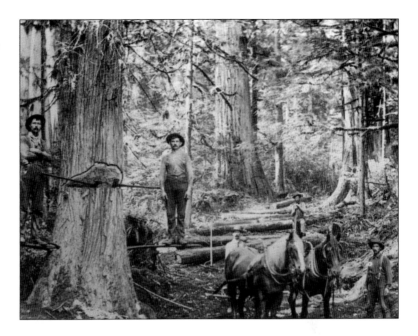

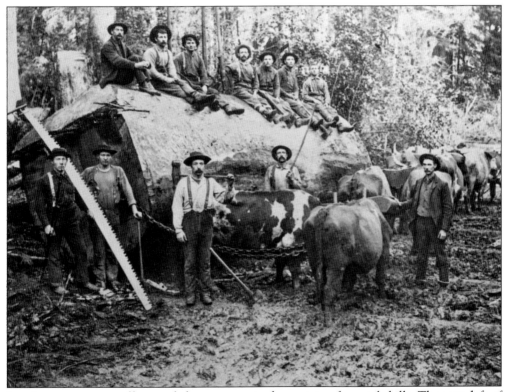

Logging was a group effort, and the crew required a variety of special skills. The man left of center holds a broom used for greasing the skids of the skid road. He was referred to as the "grease monkey." The man at center is holding a stick for driving the oxen, a "teamster" in the parlance of the day. (Courtesy of the Galen Biery Collection.)

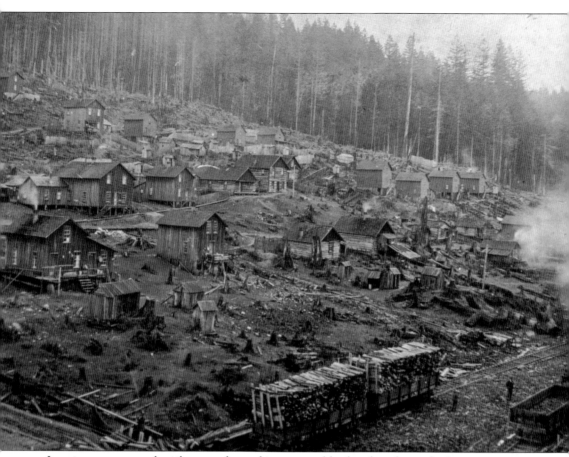

Logging camps were hastily erected—and just as quickly abandoned—as the logging operations progressed into the forests around the mountain. In some camps, the buildings were erected on skids so they could be moved when it came time to break camp. These camps included bunkhouses, mess halls, and canteens. The cooks that served up meals in the mess halls were especially important figures in the camps. Loggers typically worked 10 or 11 hours a day, six days a week, and the extreme nature of the labor meant that their food requirements were prodigious, often as much as 8,000 calories a day. A good cook could make a logging outfit successful, while a poor one could put it out of business. The cooks were assisted by "flunkies," often women, who worked as prep cooks, servers, and cleanup crew. A gong made from a circular saw blade often signaled the call to meals. (Courtesy of the Galen Biery Collection.)

Before the introduction of "steam donkeys," felled trees were dragged by oxen along skid roads, constructed of logs set in the ground. The term *skid row* has its origins in these primitive roads, which were in widespread use before the turn of the 20th century. (Courtesy of the Galen Biery Collection.)

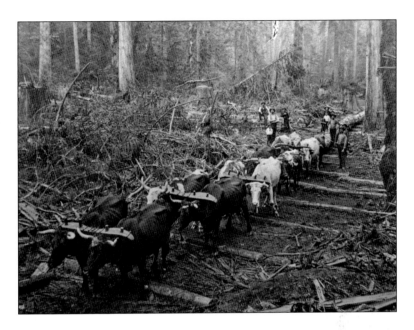

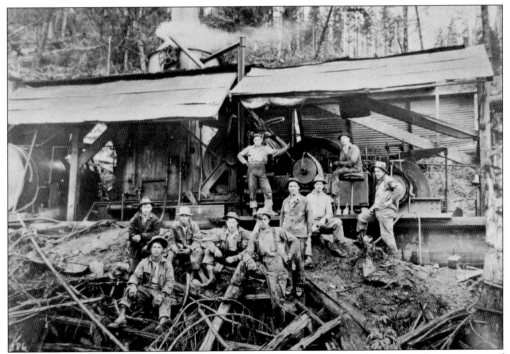

This steam donkey was located at the Forbes logging camp near Wickersham. The invention of the steam donkey in 1881 brought the practice of logging into the machine age, replacing oxen and horses. The engines were originally powered by wood, but oil had become the fuel of choice by the time their day passed. By the 1930s, gasoline-powered engines had begun replacing them. This photograph was taken by Darius Kinsey. (Courtesy of Sherman and Liz Ousdale.)

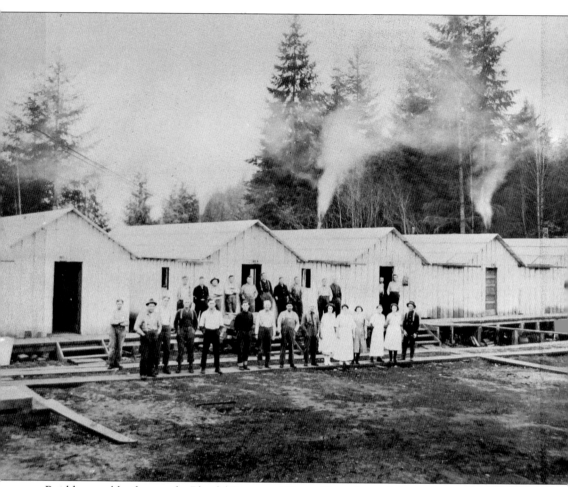

Bunkhouses, like these at the Bloedel Donovan Silvana Camp, housed the timber workers in logging camps scattered throughout the Mount Baker area. As many as 16 loggers occupied each bunkhouse, sleeping in double-decker bunks. The houses offered decidedly primitive accommodations. They were lit by kerosene lanterns, and heat was provided by wood-burning stoves. Life in the woods was hard, with long hours of backbreaking labor in conditions that were often dangerous. Accidents were commonplace, and comforts were few. Yet, despite these conditions, the industry grew, and the trees continued to fall. By 1900, there were 68 shingle mills operating in Whatcom County, producing more than $5 million in revenues annually. The timber industry had become established as a cornerstone of the local economy, a position that it would occupy for generations to come. (Courtesy of Sherman and Liz Ousdale.)

Loggers worked in teams, using axes and large crosscut saws to cut down the enormous trees in the forests around Mount Baker. The work was dangerous, and the men counted on each other to warn of falling trees with the time-honored cry of "Timber!" (Courtesy of Laura Jacoby; Galen Biery Collection.)

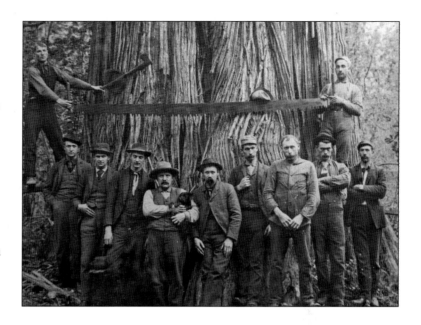

Horse and wagon move finished wood products at the Bellingham Bay Logging Company at Maple Falls. For the people who lived in the shadow of Mount Baker, the forests were a seemingly inexhaustible bounty, and a way of life. The culture that grew up around those who made their living in the woods emphasized self-reliance and independence, a legacy that lives on into the present day. (Courtesy of Wes Gannaway.)

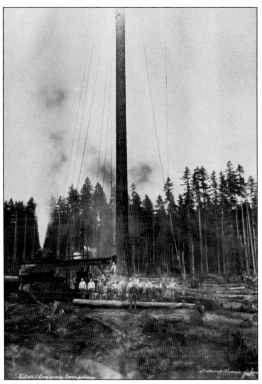

Darius Kinsey took this photograph of a spar tree rising above the Silver Lake logging camp. The spar, selected for its height and strength, was used as an anchor for the cables. A steam donkey sits at its base, emitting a trademark cloud of steam. (Courtesy of Sherman and Liz Ousdale.)

The introduction of railroads changed the very nature of logging in the 1890s. Logging companies built spur rails that branched off of the mainline, and used trains to haul logs in ever-increasing quantities. Many of the trains were manufactured by Baldwin Locomotive Works of Philadelphia, Pennsylvania. (Courtesy of the Galen Biery Collection.)

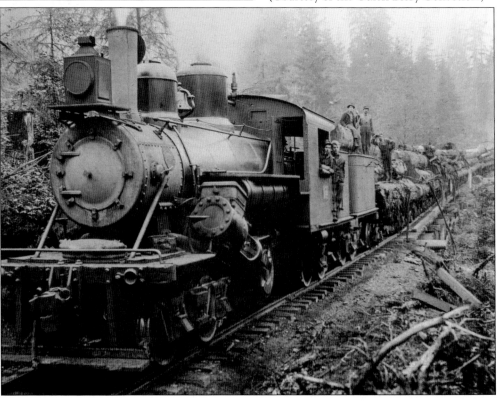

Rail spurs were built and maintained by the logging companies to facilitate the delivery of timber to market, via connections with the Bellingham Bay and British Columbia Railway. Some of these construction projects were epic. This spur at Chinn Camp near Maple Falls climbed a 4,000-foot incline. (Courtesy of Sherman and Liz Ousdale.)

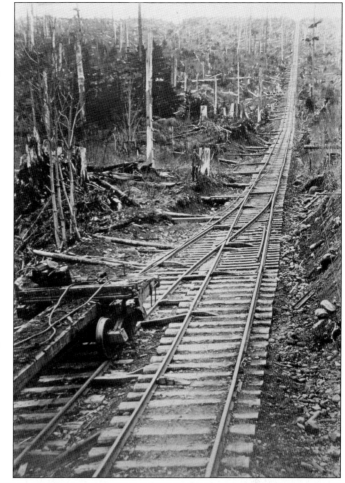

This 1910 photograph, taken by Darius Kinsey, of the Chinn logging camp on Slide Mountain shows the scale of timber activities in the Nooksack River Valley. Vast tracts of virgin forest were leveled at a furious pace, fed by increasing demand and ever-expanding railroad access. (Courtesy of the Francis B. Todd Collection.)

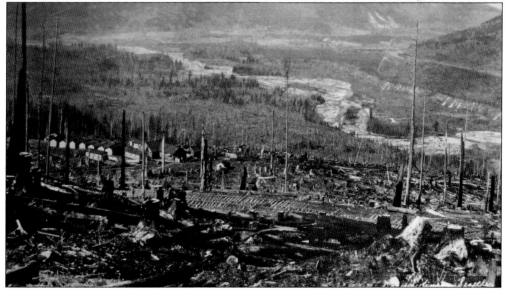

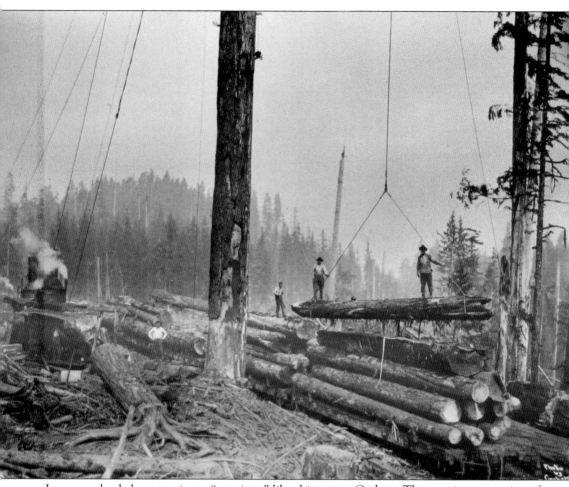

Logs were loaded onto trains at "crossings," like this one at Corbett. The ongoing expansion of the railroads allowed loggers to access forests deeper and deeper into the mountains, opening up new stands of virgin trees to the bite of the saw. The efficiencies of moving timber via railroad also greatly reduced transportation costs for Whatcom County timber companies, allowing them to become competitive with producers in the Midwest, who were struggling with shortages as a result of rapidly dwindling supply. In 1880, Washington State was 31st among US states and territories in timber production. By 1890, it ranked fifth. This growth created wealth, which in turn was invested into opening new country to the saw. The relationship also benefited the railroad, which owned vast tracts of land across the region and was itself one of the logging industry's best customers. (Courtesy of Sherman and Liz Ousdale.)

After the advent of railroads, the old ways and new methods worked together. Oxen brought the cut logs to railroad spurs, where they were loaded onto trains. The platforms beside the track were positioned above the rails, which meant that off-loaded logs could be rolled onto the train cars. (Courtesy of the Galen Biery Collection.)

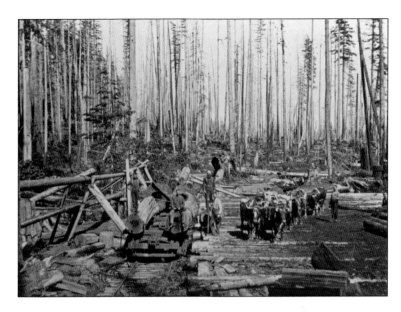

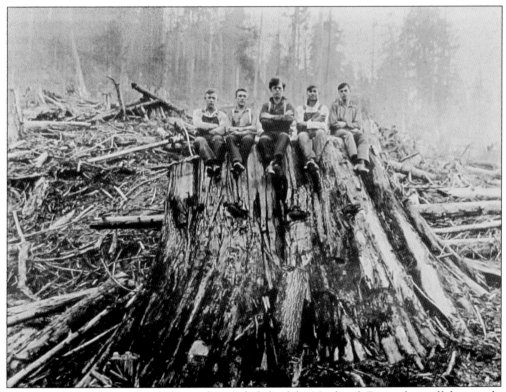

Loggers at Saxon Camp, located near the south fork of the Nooksack River, show off their work. Ed Bakke (center) and fellow workers routinely cut immense trees from the stands of Douglas fir that covered the river valleys around the mountain. By the 1920s, Whatcom County was producing more than 340 million board feet of lumber annually. (Courtesy of Sherman and Liz Ousdale.)

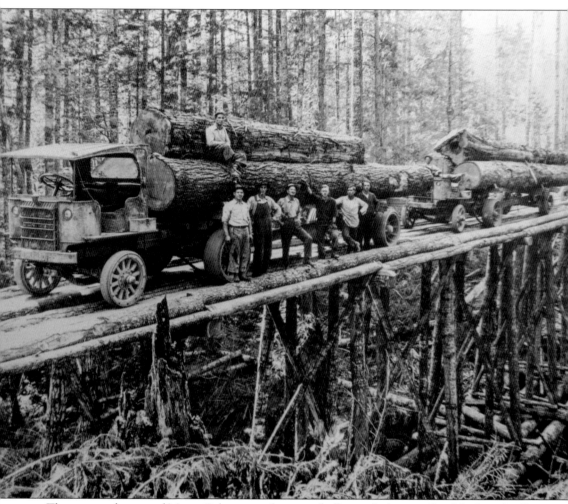

The topography around Mount Baker created serious challenges for loggers. Creek beds and gullies presented obstacles to moving the cut logs, necessitating improvised engineering projects for the logging companies. Bridges like this one could be built in a few days. To test the load-bearing capacity of a newly constructed bridge, loggers would position the truck at the start of the bridge and place a weight on the gas pedal, causing the truck to slowly cross without a driver inside. Once across, a man would jump in and drive the truck away. After an area was logged, these temporary spans were often abandoned and left to rot away in the forest. Remnants of bridges like this one can still be found in the timberlands that surround the mountain, a reminder of those rough and ready days. (Courtesy of the Galen Biery Collection.)

Four

THE MOUNT BAKER MARATHON

Considered America's first endurance race, the Mount Baker Marathon was held for three years (1911–1913). Begun in response to a longstanding rivalry between the mountain villages of Glacier and Deming (each considered themselves "the gateway" to Mount Baker), competitors raced from Bellingham to the summit of 10,778-foot Mount Baker and back again—116 miles of mud, sweat, and glory. The race began with contestants riding to the base of the mountain in either Model Ts or on a special steam train. The train stopped at Glacier, and from there, the runners climbed the Glacier Trail, a 28-mile round-trip to the summit. The automobiles carried the racers to Heisler's Ranch in Deming, where they ran up the Deming Trail, a 32-mile round-trip. Either way, the elevation gain was a staggering 9,700 feet and culminated in a dash up crevasse-riddled glaciers to the peak, where judges were stationed. The first year of the marathon, Harvey Haggard, a local mule packer, was the first down the mountain. He boarded the train for the ride into Bellingham, and what seemed like certain victory, and stripped down to avail himself of a massage. The train collided with a bull that had wandered onto the tracks, derailing it and pitching a naked Haggard into the brush. Dazed, but unhurt, Haggard continued on via a combination of horseback, buggy, and automobile, but he finished second to Joe Galbraith. Haggard would redeem himself by winning the marathon the next year. In 1913, a storm enveloped the mountain on race day. The judges abandoned the summit, but race organizers decided to run the race anyway. Confusion ensued. Some of the racers turned back at a high saddle, while others pressed on to the summit. Descending a glacier, Victor Galbraith (Joe's cousin) fell 40 feet into a crevasse. Only a small ledge kept him from falling to his death. Miraculously, after five hours in the crevasse, he was rescued by his cousin Joe. The race ended in chaos and confusion; only sheer luck had prevented fatalities. After three years, the Mount Baker Marathon was dead.

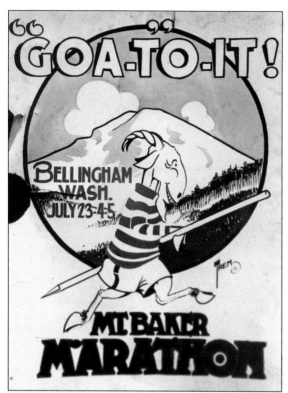

This poster for the Mount Baker Marathon featured "Baker" the goat. The marathon was conceived by the Mount Baker Club, a Bellingham business organization, in hopes of drawing attention to the mountain as a possible national park. The club, noting how tourists began to visit Mount Rainier after it was established as a national park in 1899, wanted to attract them to Mount Baker. (Courtesy of the *Bellingham Herald*.)

The Mount Baker Marathon's summit judges on Grant Peak, the highest point on glacier-covered Mount Baker. The judges, stationed on the summit to verify each racer's success at reaching the top, endured bitterly cold conditions. After suffering nearly catastrophic exposure the first year, they erected a small shelter on the summit plateau for the last two years of the race. (Courtesy of the Galen Biery Collection.)

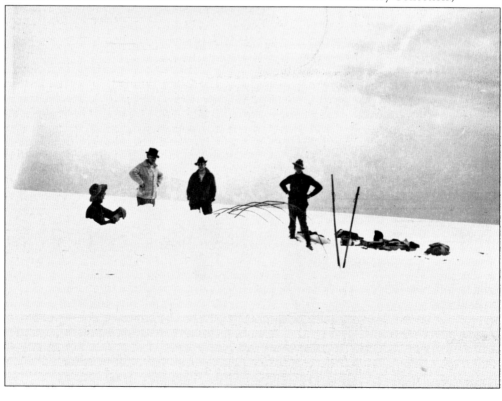

Joe Galbraith, a farmer from the village of Acme, was the winner of the first Mount Baker Marathon, in 1911. Galbraith, the son of a homesteader in the Nooksack Valley, also served as a ranger and was very active as an early climber and hiker on the mountain. (Courtesy of Gail Everett.)

Nearing the finish line in 1911, Joe Galbraith and driver Hugh Diehl speed down Elk Street in Bellingham to the end of the race at the chamber of commerce office. Galbraith won the race but was prevented from competing the following year when he broke his arm in an automobile accident while training. (Courtesy of the Galen Biery Collection.)

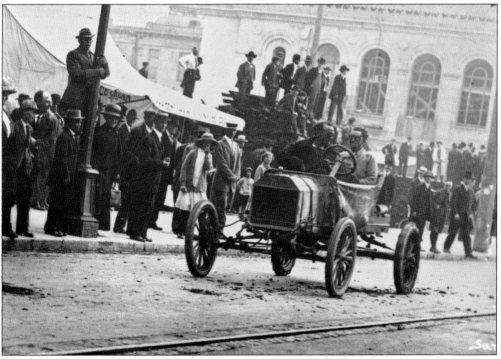

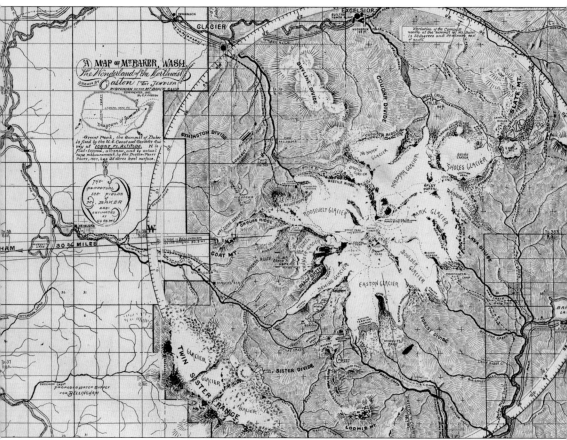

This map of the Mount Baker Marathon route, created by Charles Easton, details the two alternative routes to the summit: the Glacier Trail (starting near Glacier, upper left) and the Deming Route (starting near Heisler's Ranch, middle left). Once they reached the tree line, the runners ran up snowfields and across some of the mountain's largest glaciers in canvas shoes or hobnailed logging boots. At the top of the mountain, judges were stationed to verify their success at summiting. By the time the racers had returned to the trailheads for either the automobile or train ride back to Bellingham, many were delirious with exhaustion. Some had to be tied to the seats of the Model Ts to prevent them from falling out on the high-speed ride back through the foothills. (Courtesy of the Galen Biery Collection.)

Harvey Haggard comes down the Glacier Trail in 1911 to catch the train into Bellingham. Haggard was a mule packer from nearby Maple Falls and a favorite of the crowd. Although he had a comfortable lead, events were to conspire against him, costing him the victory. (Courtesy of the Galen Biery Collection.)

Roy D. Mote, an employee of Hugh Diehl, is seen here on a field trial with "Betsy" before the 1911 race. The vintage automobiles carried the racers over the primitive roads to the start of the Deming Route at Heisler's Ranch, attaining speeds in excess of 60 miles per hour. Some of the runners noted that this was the most dangerous part of the race. (Courtesy of Todd Warger.)

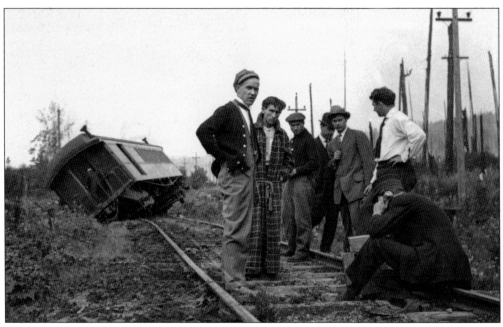

In 1911, Harvey Haggard was the first runner down the mountain. He then boarded the special train back to Bellingham. After coming on board, Harvey stripped down for a rubdown just as the train rounded a bend and collided with a bull that had wandered onto the track, derailing the train. Dazed but unhurt, Haggard is shown here in a bathrobe after the collision. (Courtesy of the Galen Biery Collection.)

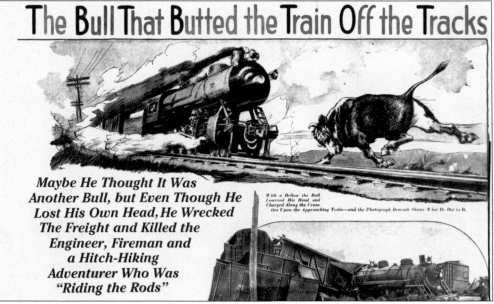

This cartoon appeared in the *Seattle Times* in 1911, depicting the famous collision between the Bellingham Bay–British Columbia No. 3 Special and an 1,800-pound red bull. Hyperbole aside (no one was actually killed), the bull derailed the train and cost front-runner Harvey Haggard the victory. He still managed to finish second after finally reaching the finish line, fainting twice along the way. (Courtesy of the Galen Biery Collection.)

The Herald Cup was awarded to Joe Galbraith on August 9, 1911. Galbraith's winning time was 12 hours, 28 minutes. His victory was made possible when front-runner Harvey Haggard's train was derailed by a bull. The crowd was sympathetic to Haggard, crowning him "King of Glacier" and raising $50 for him by passing the hat. (Courtesy of Gail Everett.)

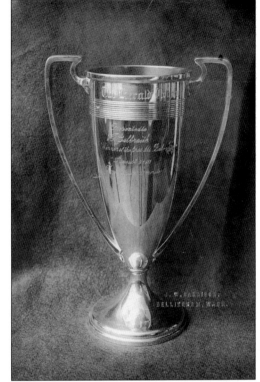

Following the 1911 marathon, the 1,800-pound bull that had derailed the train carrying Harvey Haggard was butchered and barbecued in a celebration attended by hundreds of locals at Deming Park. Farmer Daniel J. Loop, the owner of the bull, successfully sued the railroad and was awarded $40 for the loss. (Courtesy of the Galen Biery Collection.)

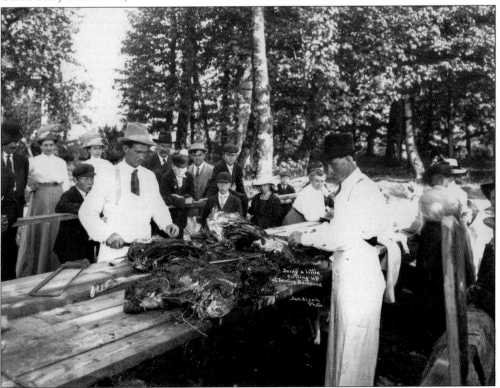

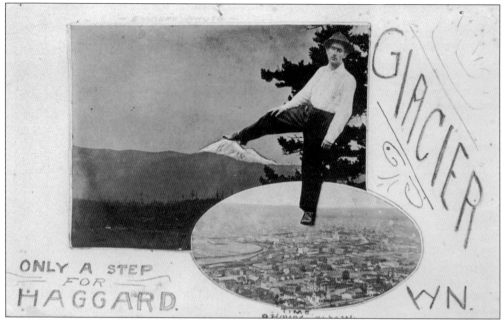

A postcard produced after the 1911 marathon featured local hero Harvey Haggard with one foot in downtown Bellingham and the other atop Mount Baker. His victory in the 1912 marathon would mark the end of his racing days. Haggard became a symbol of perseverance and homegrown pluck. (Courtesy of Todd Warger.)

The 1912 race begins! The starting line for the Mount Baker Marathon was in front of the Bellingham Chamber of Commerce, in downtown Bellingham on Dock Street (now Cornwall Avenue). Both "Betsy" and "Betsy 2" were stripped-down Model Ts, modified for use in the race by Hugh Diehl, owner of Diehl Ford, the third-oldest Ford dealership in the world. (Courtesy of the Galen Biery Collection.)

Seen here on the Glacier Trail in 1912 are Victor Norman (left), Harvey Haggard (center), and Paul Westerland. Haggard took the Herald Cup in 1912, vindicating himself after finishing second in 1911 when his train derailed on the way back to Bellingham. The Glacier Trail, though shorter than the Deming Trail, was considered more difficult. (Courtesy of the Galen Biery Collection.)

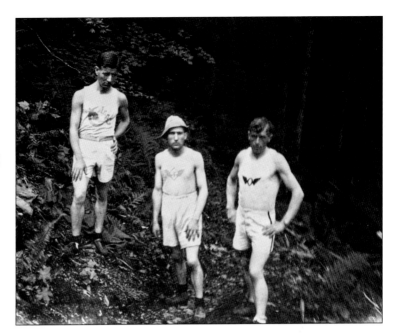

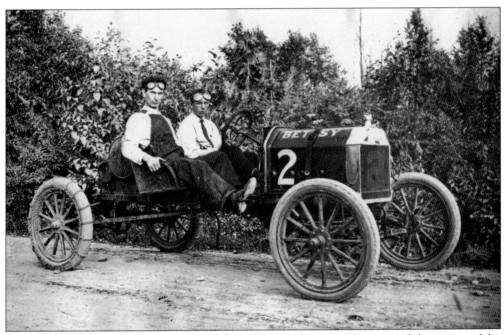

Mount Baker Marathon racer Turner Riddle (left) sits in Betsy 2. The automobile portion of the epic race involved driving from Bellingham to Heisler's Ranch, located beside the middle fork of the Nooksack River. From there, the racers ran up the Deming Trail to the summit of Mount Baker. Turner's driver is Hugh Diehl. (Courtesy of Phyllis Riddle.)

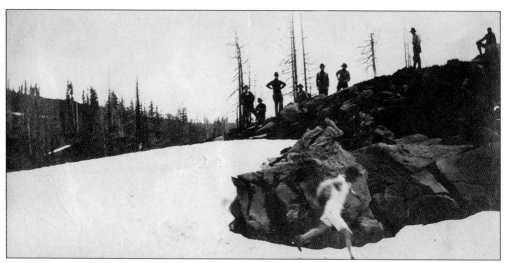

On the way down the mountain, runners on the Deming Route reached Mazama Park, a meadow that offered a brief respite from the precipitous slopes. Spectators and family members gathered here to provide food and clothing to the exhausted racers. (Courtesy of Margaret Hellyer.)

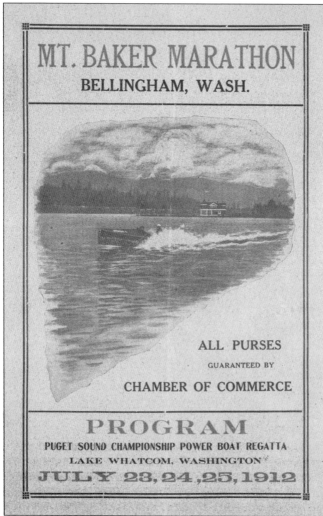

MT. BAKER MARATHON
BELLINGHAM, WASH.

ALL PURSES

GUARANTEED BY

CHAMBER OF COMMERCE

PROGRAM
PUGET SOUND CHAMPIONSHIP POWER BOAT REGATTA
LAKE WHATCOM, WASHINGTON
JULY 23, 24, 25, 1912

The 1912 program for the marathon featured a powerboat regatta, one of many events that were added to the festivities. The regatta was held on nearby Lake Whatcom, site of White City, an amusement park on the shores of the lake that opened in 1907–1908. White City closed in 1914. (Courtesy of the Bellingham Library.)

The 32-mile Deming Route ascended Mount Baker from Heisler's Ranch near Deming. Runners arrived at the ranch in automobiles and ran up the south side of the mountain, climbing the Deming Glacier beneath the towering Black Buttes to the summit. The Deming Route was longer than the Glacier Route but was considered a more gradual ascent. (Courtesy of Todd Warger.)

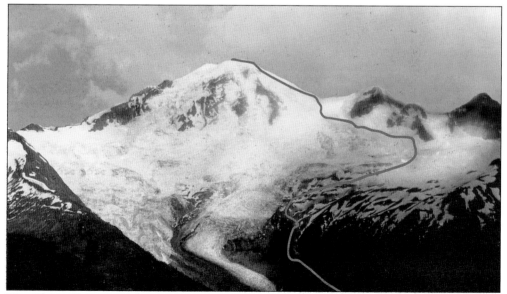

The Glacier Route was shorter, but steeper. Racers ran 28 torturous miles up trails slick with mud and awash with the glacial melt of streams swollen by rain before reaching the permanent glacial ice. The total elevation gain to achieve the summit was a staggering 9,700 feet. (Courtesy of Todd Warger.)

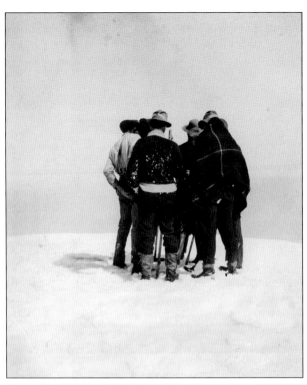

Judges stationed on top of Mount Baker sign the certificate of a racer to certify that he had achieved the summit. At this point, many of the runners were nearly hypothermic, and race rules required them to spend four minutes on top before heading down. (Courtesy of the Galen Biery Collection.)

This race certificate, worn in a pouch by runner John Magnuson during the 1912 competition, was signed by the summit judges to certify that he had reached the top. Magnuson, 36, was the oldest of the mountain runners and was the first racer down the Deming Trail. Known as "Hard-luck" Magnuson, he finished fourth after automobile troubles delayed him on the way back to Bellingham. (Courtesy of the Deming Library.)

Mount Baker Marathon Certificate

No. 1

This Certificate, When countersigned by a majority of the Referees stationed on the Summit of Mount Baker, and when attested by the President of the Mount Baker Club and the Chairman of the Contest Committee

Bears Witness that _J. K. Magnuson_

was a contestant in said Mount Baker Marathon; that he started on said contest from the Chamber of Commerce, in the City of Bellingham, Whatcom County, Washington, at _11_ p. m. on _Wednesday_ _July 24 31_ th, 1912; that he arrived at the Summit of Mount Baker at _5_ a. m. on _Aug 1st_ th, 191_2_ and completed the race, arriving at the said Chamber of Commerce Rooms on his return at _10:14_ o'clock _A_ m. on said _1st_ th day of _August_, 1912, making round trip of _88_ miles in _11_ hours, _14_ minutes, and finishing _sixth_ in the contest.

Henry EngbergPresident.

R. H. GreeneSecretary.

Countersigned:

Referees at Summit.

GOAT-TO-IT!

Attest:

President.

Chairman Contest Committee.

66

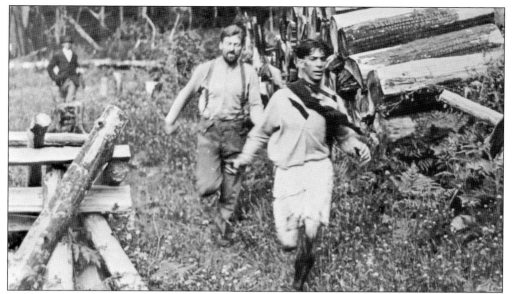

Mountain runner Victor Norman reaches Heisler's Ranch at the bottom of the Deming Route during the final Mount Baker Marathon in 1913. Bad weather on the mountain caused the judges to abandon the summit. They advised runners to turn around at a high saddle. Some summited anyway, resulting in confusion and acrimony about who the winner was. Behind Norman is "pace man" George Huber. (Courtesy of the Galen Biery Collection.)

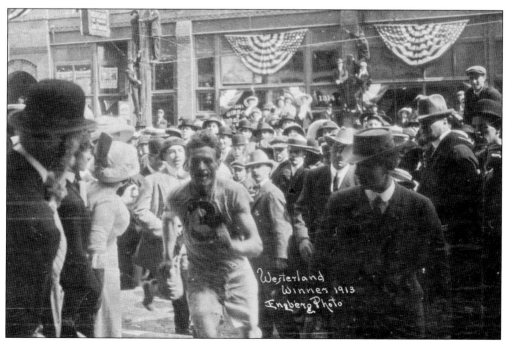

Paul Westerland, 24, approaches the finish line at the Bellingham Chamber of Commerce. Westerland, a professional runner from California, had emigrated from Finland in 1906. He had won the Mount Wilson Marathon in California and unsuccessfully tried out for the US Olympic team in 1912. (Courtesy of the Galen Biery Collection.)

Westerland ran in the marathon in 1912 and 1913. He finished fourth in 1912 and was one of the disputed "winners" in 1913. Subsequently, he won a 28-mile-long "race for blood" in 1913 against the other disputed winner, Millard Burnside, with a still-unbeaten time of six hours, two minutes. (Courtesy of the Galen Biery Collection.)

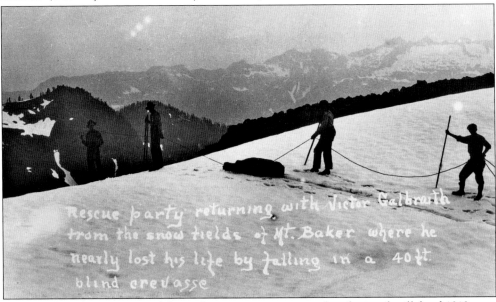

Rescue party returning with Victor Galbraith from the snow fields of Mt. Baker where he nearly lost his life by falling in a 40 ft. blind crevasse

Victor Galbraith is transported down the mountain on a stretcher during the ill-fated 1913 race. He had been rescued from a crevasse by his cousin Joe (winner of the 1911 marathon). This near-fatal accident, combined with the confusion caused by bad weather on the mountain, spelled the end of the Mount Baker Marathon. (Courtesy of the Galen Biery Collection.)

Five

THE MOUNT BAKER LODGE

In the summer of 1894, civil engineer Bert Huntoon and draftsman H.W. Wellman were sent by the Washington State Roads Commission to seek out possible routes for a proposed Cascade State Wagon Road. Their arduous travels on foot took them through rugged terrain along the south fork of the Nooksack River and eventually up to the idyllic alpine meadows around Austin Pass, located at an elevation of 4,700 feet on the slopes of Mount Baker. Huntoon, an accomplished photographer with an eye for beauty, was impressed with what he saw. Upon his return to Bellingham, his rhapsodic descriptions of the area fired the imaginations of the townsfolk and stoked the ambitions of local officials, who had begun to think about exploiting the scenic beauty of the Mount Baker area.

By the 1920s, roads were penetrating into the foothills, and there was talk of building a road all the way to Mount Baker. With access to the mountain, boosters maintained, a lodge could finally be built to attract tourists to the mountain's slopes. The *Lynden Tribune* famously declared that "Whatcom County's greatest undeveloped asset is Mount Baker. The moment a satisfactory road and a tourist hotel are built on the mountain, the stream of tourists will begin to arrive."

With the financial assistance of the National Forest Service, construction of just such a road began in 1921. A cadre of Bellingham's business leaders formed the Mount Baker Development Company and leased five acres beneath Austin Pass on which to construct a hotel. In 1923, they set to work, and the Mount Baker Lodge opened for business on July 14, 1927, with Huntoon as general manager. More than 11,000 guests checked in that first year, prompting the construction of an Annex in 1928.

Then, in the early morning hours of August 5, 1931, a fire broke out, possibly caused by faulty wiring. The blaze spread quickly and, despite the efforts of lodge workers, the main building was quickly consumed by flame. The Annex was spared, but, by 8:00 a.m., all that remained of the lodge was its foundation, fireplace, and stone chimney.

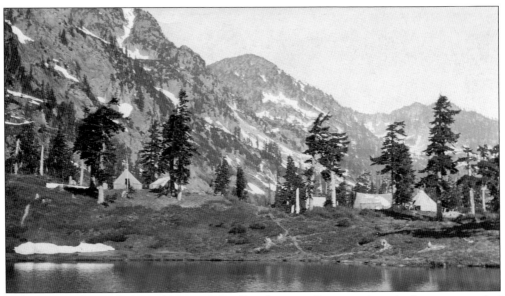

In early 1923, the newly formed Mount Baker Development Company leased a five-acre parcel of land at Heather Meadows from the US Forest Service for $125 per year. The site, which had been identified by Bert Huntoon in 1894, was established as a camp for tourists, who were brought in by packhorses. The following year, construction of the Mount Baker Lodge began in the meadow. (Courtesy of Gordy Tweit.)

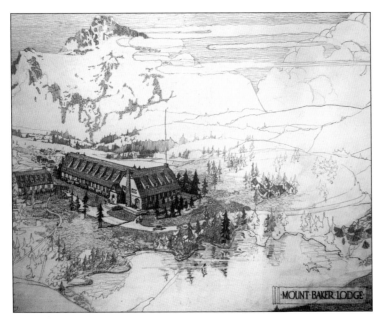

This artist's rendering imagined a lodge built of stone, quarried from the columnar basalt that was prevalent in the area around the building site. Ultimately, however, the lodge was constructed of cedar, sourced from nearby land owned by the Mount Baker Development Company. (Courtesy of the Galen Biery Collection.)

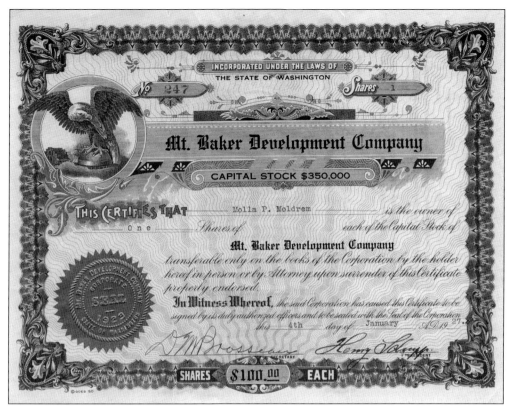

To help finance construction of the lodge, the Mount Baker Development Company began issuing stock certificates in 1925, which were sold through the chamber of commerce. In the first two hours, 859 certificates, valued at $100 each, were sold. The names of the purchasers were engraved in copper and mounted in the lodge upon its completion. (Courtesy of Gordy Tweit.)

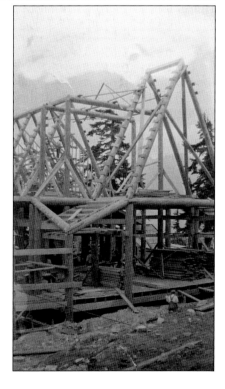

Construction of the lodge is seen here in 1926. Until the Mount Baker Highway was completed in the fall of that year, building materials were transported by packhorses. The site was originally known as Austin Pass Meadows, but it was rechristened Heather Meadows, a name considered better suited to marketing the lodge. (Courtesy of the Francis B. Todd Collection.)

The lodge was made possible by the construction of the Mount Baker Highway, which linked Bellingham and the mountain. Originally, the developers of the lodge had lobbied Congress to establish a national park at Mount Baker, hoping to replicate the success enjoyed by the communities around Mount Rainier National Park, established in 1899. Unfortunately, the proposal was shelved when World War I intervened. After the war, funding from the US Forest Service became available to construct the Mount Baker Highway, but the agency opposed the national park concept and, as a result, the dream of a Mount Baker National Park was effectively dead. Construction of the eight-foot-wide gravel "highway" along the north fork of the Nooksack River began in 1921. (Courtesy of Todd Warger.)

The *Bellingham Herald* ran this cartoon, drawn by Whipple Chester, in 1927, lauding Bert Huntoon's role in making possible the construction of the Mount Baker Lodge. Along with Mounts Shuksan and Baker, which are fancifully rendered, the drawing highlights the area's bears and oversized trees. (Courtesy of the *Bellingham Herald*.)

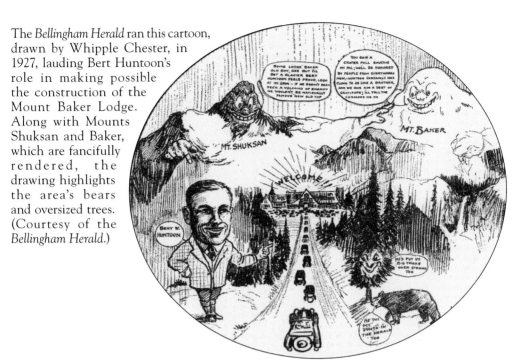

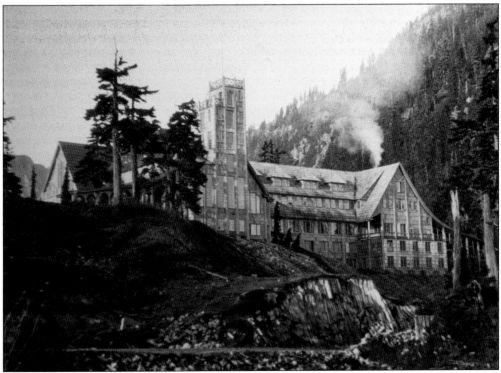

The lodge featured a 70-foot-tall, log-constructed observation tower that visitors could climb via a set of stairs. At the top, a viewing area held up to 50 people at a time. This was a favorite gathering place for guests interested in watching the alpenglow on Mount Shuksan at sunset. (Courtesy of the Galen Biery Collection.)

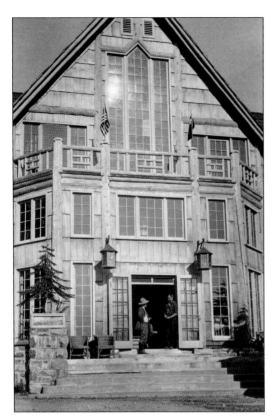

The impressive front entrance to the lodge faced majestic Mount Shuksan across what was then known as Sunrise Lake. The L-shaped building measured 210 feet long, and its width ranged from 50 to 130 feet. The cedar shakes used were milled nearby. (Courtesy of Gordy Tweit.)

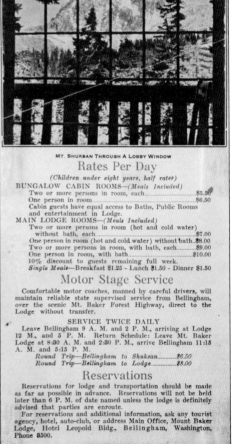

MOUNT BAKER LODGE

MT. SHUKSAN THROUGH A LOBBY WINDOW

Rates Per Day

(Children under eight years, half rates)

BUNGALOW CABIN ROOMS—*(Meals Included)*
Two or more persons in room, each.........................$5.50
One person in room...$6.50
Cabin guests have equal access to Baths, Public Rooms and entertainment in Lodge.

MAIN LODGE ROOMS—*(Meals Included)*
Two or more persons in room (hot and cold water) without bath, each...$7.00
One person in room (hot and cold water) without bath..$8.00
Two or more persons in room, with bath, each...........$9.00
One person in room, with bath................................$10.00
10% discount to guests remaining full week.
Single Meals—Breakfast $1.25 - Lunch $1.50 - Dinner $1.50

Motor Stage Service

Comfortable motor coaches, manned by careful drivers, will maintain reliable state supervised service from Bellingham, over the scenic Mt. Baker Forest Highway, direct to the Lodge without transfer.

SERVICE TWICE DAILY
Leave Bellingham 9 A. M. and 2 P. M., arriving at Lodge 12 M., and 5 P. M. Return Schedule: Leave Mt. Baker Lodge at 8:30 A. M. and 2:30 P. M., arrive Bellingham 11:15 A. M. and 5:15 P. M.
Round Trip—Bellingham to Shuksan............$6.50
Round Trip—Bellingham to Lodge...............$8.00

Reservations

Reservations for lodge and transportation should be made as far as possible in advance. Reservations will not be held later than 6 P. M. of date named unless the lodge is definitely advised that parties are enroute.
For reservations and additional information, ask any tourist agency, hotel, auto-club, or address Main Office, Mount Baker Lodge, Hotel Leopold Bldg., Bellingham, Washington, Phone 8500.

PRINTED IN U. S. A.

This brochure, printed during the Mount Baker Lodge's first year of operation in 1927, detailed the rates for rooms in the lodge and cabins, meals, and the cost of being transported "by careful drivers" from Bellingham to the mountain. Upon opening, the lodge attracted guests from the local region and from farther afield. (Courtesy of the Galen Biery Collection.)

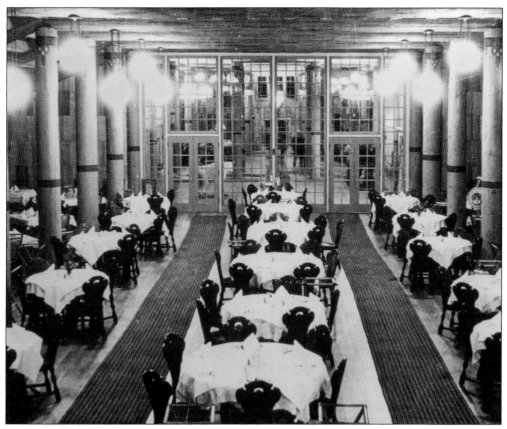

The lodge boasted a grand dining room that measured 90 by 50 feet and had the capacity to seat 300 guests for dinner. The room was expandable, thanks to glass doors and windows that could be removed to enlarge it for special occasions. A balcony provided a place for musicians, who periodically entertained diners at galas. (Courtesy of the Galen Biery Collection.)

Among the various recreational pursuits available at Mount Baker was this miniature golf course, constructed in an alpine meadow beside the lodge. In addition to miniature golf, visitors enjoyed boating, swimming, fishing, hiking, and guided mountain climbing. But for some, relaxing and enjoying the scenery was activity enough. This photograph was taken in 1930. (Courtesy of the Galen Biery Collection.)

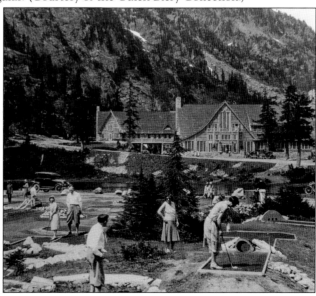

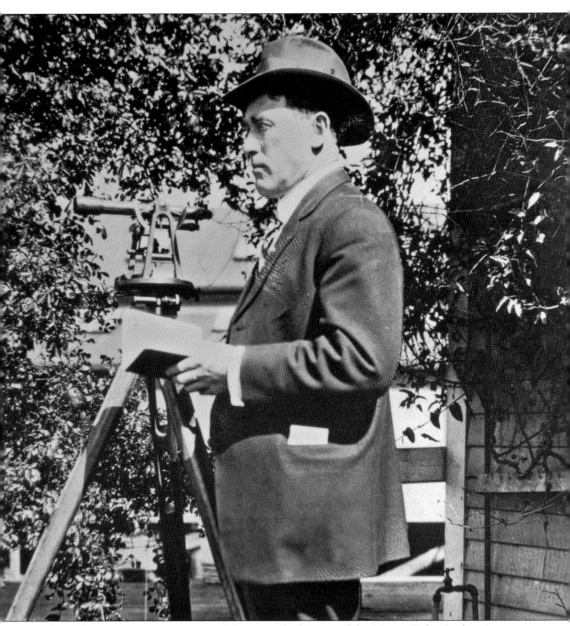

Bert Huntoon was an instrumental figure in the history of the Mount Baker Lodge. A surveyor, engineer, and photographer, he played a pivotal role in the development of the lodge by shaping public opinion with his accounts—and expertly crafted images—of the beauty of the landscapes on the slopes of the mountain. A significant figure in the Pacific Northwest from the 1890s until his death in 1947, he was also a key figure in the establishment of Bellingham's Sehome Park and the construction of Chuckanut Drive, Washington State's first designated scenic road. In 1923, he became general manager of the Mount Baker Development Company and was outside of the lodge photographing the sunrise when it burned to the ground in 1931. In his later years, Huntoon devoted much of his time to photography. His images of the area reveal a deeply felt love of nature and an eye for beauty. Huntoon Point, the highest spot on Mount Baker's Kulshan Ridge, is named after him. (Courtesy of the Galen Biery Collection.)

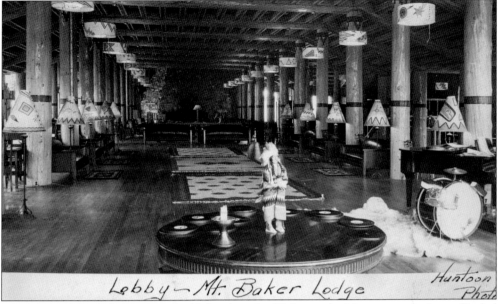

The lobby of the lodge measured 130 feet long by 50 feet wide. Numerous windows afforded breathtaking views of the surrounding mountains. Decor was inspired by native art, with a color scheme of red and grey. Electric lights were operated by hydropower produced by the nearby Bagley Creek Dam. (Courtesy of the Galen Biery Collection.)

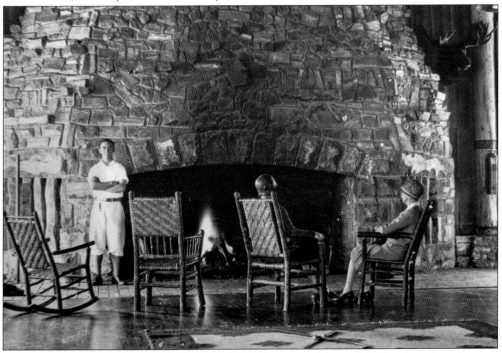

The fireplace in the lobby was built to epic proportions and burned 10-foot-long logs. It was a favorite gathering place for guests to warm themselves in the evenings after a day spent hiking in the surrounding mountains. The lobby's gleaming oak floors were ideal for dancing. (Courtesy of the Galen Biery Collection.)

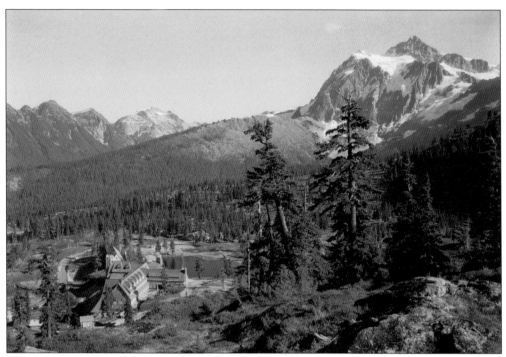

In its heyday, the Mount Baker Lodge presided over a resort complex that included the Annex, built directly behind it in 1928. Across Sunrise Lake is the Heather Inn, where lodge staff were housed and fed. This photograph was taken in 1929, two years after the lodge opened. (Courtesy of Todd Warger.)

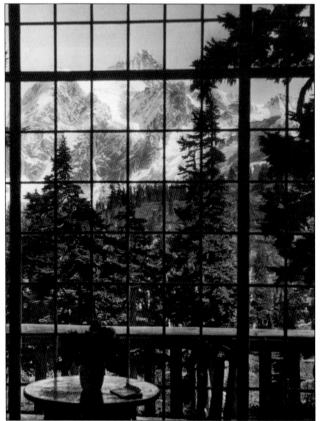

The lodge was built to maximize the spectacular views of the surrounding alpine country, especially the close-at-hand Mount Shuksan. Windows were oriented to highlight the views of this magnificent mountain, and a dozen writing desks, stocked with stationary and pens, were strategically situated to offer guests an inspiring view while they wrote letters home. (Courtesy of the Galen Biery Collection.)

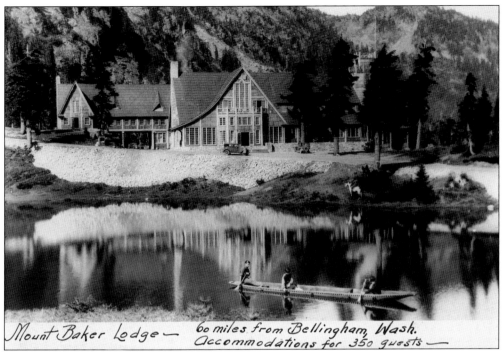

Mount Baker Lodge — 60 miles from Bellingham, Wash. Accommodations for 350 guests —

The design of the lodge was modeled on the architectural style of Swiss mountain lodges. The rooflines were steeply sloped to shed the prodigious amounts of snow that fell at the high altitude in the precipitation-rich Northwest. Among the many activities enjoyed by visitors, boating on Sunrise Lake was a favorite. (Courtesy of Gordy Tweit.)

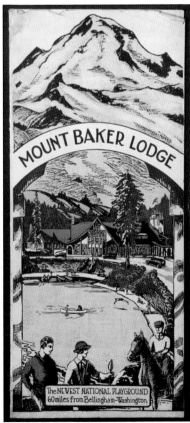

The Mount Baker Development Company promoted the lodge as one of the Pacific Northwest's premier tourist destinations. The creation of Mount Rainier National Park had fueled interest in the scenic attractions of the region, and hopes were high that Mount Baker could become an equally popular draw. (Courtesy of the Galen Biery Collection.)

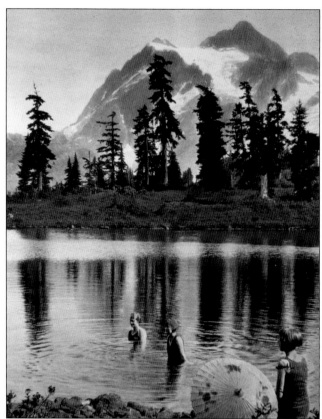

Reflection Lake, located just steps from the lodge, offered a place for guests to enjoy a refreshing dip on summer afternoons. Despite the high elevation, the water was reasonably warm on a sunny day, and the lakeside scenery, beneath the gleaming face of Mount Shuksan, was picture-perfect. (Courtesy of the Galen Biery Collection.)

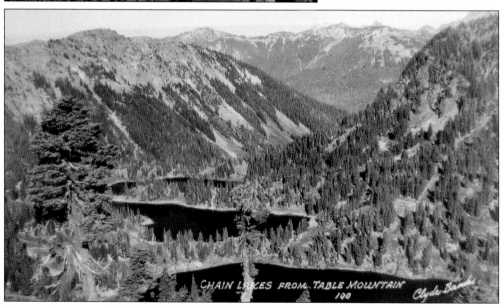

CHAIN LAKES FROM TABLE MOUNTAIN
100

Among the many destinations that guests visited on hiking forays from the lodge, the Chain Lakes were one of the most popular. Such outings were organized by lodge staff and became a major draw, affording visitors the opportunity to enjoy the alpine vistas that surrounded Mount Baker. (Photograph by Clyde Banks; courtesy of the Francis B. Todd Collection.)

The lodge gave tourists from Seattle and beyond a chance to "get away from it all" and experience the majestic high country of the North Cascades. Among the attractions were breathtaking scenery and plentiful wildlife. Here, a visitor feeds a bear—a popular, if dubious, proposition. (Courtesy of Gordy Tweit.)

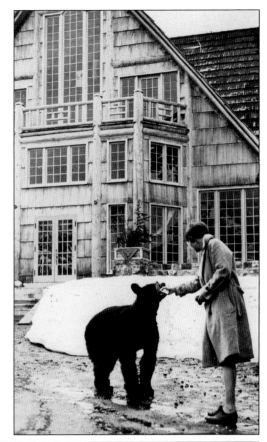

By 1929, adventurous visitors began to experiment with skiing at Mount Baker, despite the fact that the lodge was closed in winter and often buried in snow. These hearty souls spent the night in the town of Glacier and hiked to the lodge area. In January of that year, a group of 21 visited the area on a jaunt organized by the Mount Baker Club. (Courtesy of Gordy Tweit.)

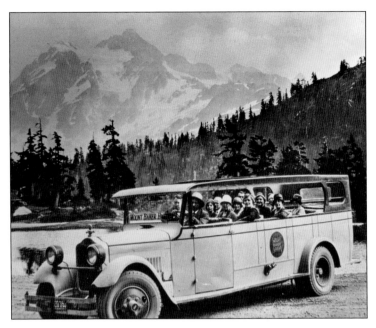

The Mount Baker omnibus is seen here around 1930. Transportation to the lodge was facilitated by several omnibuses and touring cars that delivered guests via the newly "improved" Mount Baker Highway, an adventure in itself. Vehicles picked up passengers at the Leopold Hotel in Bellingham for the drive up to the mountain. The cost of a round-trip ticket was $8. (Courtesy of the Galen Biery Collection.)

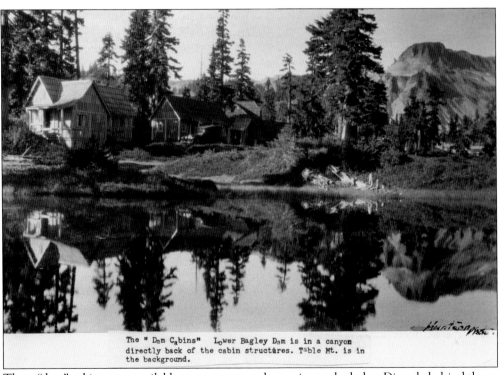

The " Dam Cabins" Lower Bagley Dam is in a canyon directly back of the cabin structures. Table Mt. is in the background.

These "dam" cabins were available to guests as an alternative to the lodge. Directly behind them, lower Bagley Creek Dam, which generated hydroelectric power for the lodge, was located in a canyon. Table Mountain, easily identified by its flat top, rises behind the cabins. (Courtesy of Gordy Tweit.)

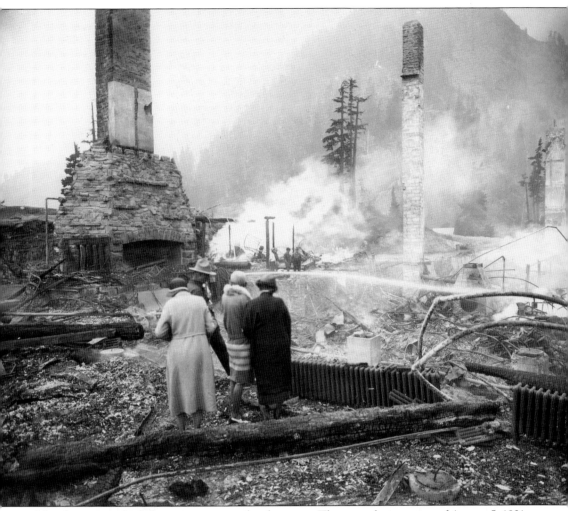

After four years, the lodge was more popular than ever. Then, on the morning of August 5, 1931, night watchman Thor Johnson smelled smoke. He sounded the alarm, but flames quickly engulfed the main building. Despite the efforts of the lodge's employees and almost 100 road workers who were in the vicinity, the fire consumed the building. Thankfully, there were only 27 registered guests in the lodge at the time and all escaped without notable injury after manager William Hahn went from room to room. The lodge's 1,900-gallon oil tank blew up, sending flames 1,000 feet into the air. By 8:00 a.m., the lodge had been reduced to a smoldering ruin. Due to calm conditions, the fire was contained to the main building, sparing the Annex, Heather Inn, and the cabins. Losses were estimated at $250,000, but insurance covered only $95,000. The board of directors of the Mount Baker Development Company met two days later and determined that the remaining buildings would stay open until the season's end after Labor Day. (Courtesy of the Galen Biery Collection.)

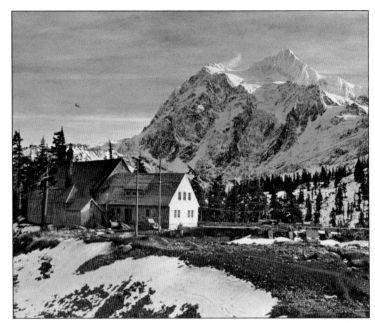

After the lodge burned down, the directors of the Mount Baker Development Company decided to remodel the Annex (pictured here after the fire) and the Heather Inn, rather than attempting to rebuild the main lodge during the Great Depression. A combination of hard times and the lack of a signature structure resulted in diminishing interest—and revenues—for the development company. (Courtesy of Gordy Tweit.)

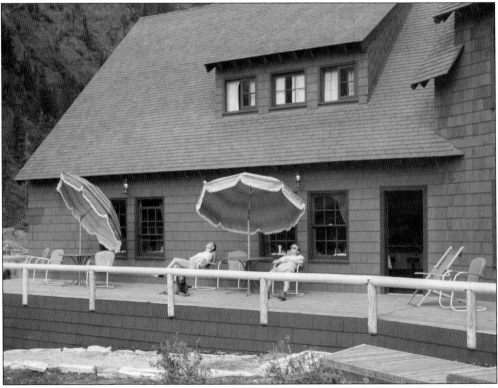

The Heather Inn closed in 1939. An addition to the Annex (shown here) was built, which now offered 22 rooms for guests, a small lobby, and a coffee shop. The Heather Inn became the property of the US Forest Service two years later. It collapsed in 1951 and was intentionally burned. The Annex was eventually converted to housing for employees of the newly developed ski area. (Courtesy of Gordy Tweit.)

Six

HOLLYWOOD COMES TO MOUNT BAKER

By the 1920s, Mount Baker was attracting interest from an unlikely source: Hollywood. Adventure movies were popular and stories set in the far north were in vogue. And so it was that Mount Baker became a stand-in for places like Alaska and the Yukon Territories of Canada. At the time, traveling with a film crew to the real Alaska was a challenging, and expensive, undertaking. Mount Baker possessed the scenic grandeur of the far northern mountains and enough remoteness to afford an authentic frontier setting.

In 1927, the year that the Mount Baker Lodge opened, William Fox Pictures filmed the production of *Wolf Fangs*, starring Charles Morton (and Thunder the dog) at the mountain. The filming was a boon for the lodge and introduced the slopes around Heather Meadows to the cognoscenti of the emerging motion picture industry.

In the winter of 1934–1935, a film crew arrived to turn Jack London's masterpiece *The Call of the Wild* into a major motion picture. Clark Gable and Loretta Young starred under the direction of William Wellman. Hollywood came calling again in the summer of 1937, when the filming of *The Barrier* turned Heather Meadows into a replica of Flambeau, a fictional town in the Yukon Territory. In 1977, scenes from *The Deer Hunter* were filmed at Heather Meadows, along Glacier Creek, and at Nooksack Falls. The glaciated peaks were an odd choice to portray the Allegheny Mountains of Western Pennsylvania, but director Michael Cimino wanted scenery that was dramatic enough to match the intensity of stars Robert De Niro, Christopher Walken, and Meryl Streep.

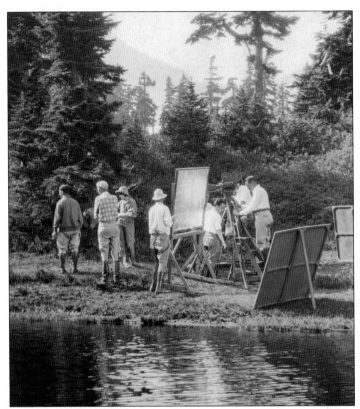

The first movie to be shot at Mount Baker was *Wolf Fangs*, in 1927. The film was directed by Lewis Seiler and starred Caryl Lincoln and Charles Morton. The newly opened Mount Baker Lodge housed the cast and crew in style. (Courtesy of Gordy Tweit.)

In *Wolf Fangs*, Caryl Lincoln plays a sheepherder's daughter saved from a pack of attacking wolves—and her brutal father—by her loyal dog, Thunder. It was her very first role in what would be a long career that included more than 30 films. (Courtesy of Gordy Tweit.)

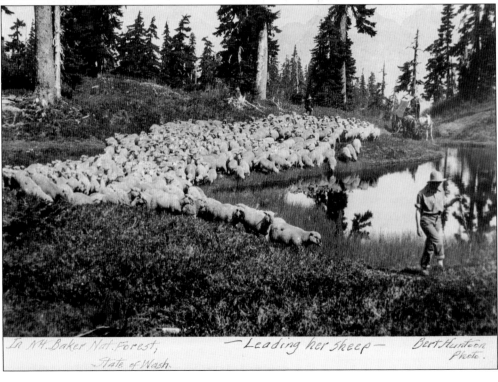

In Mt. Baker Nat. Forest, State of Wash. — Leading her sheep — Bert Huntoon Photo.

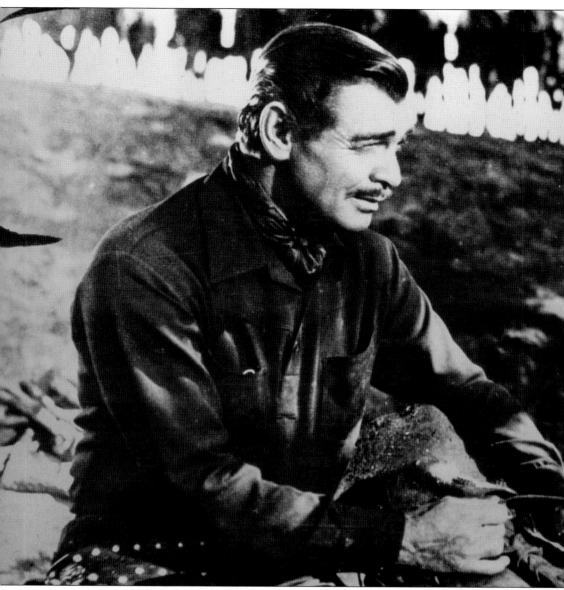

Except for the howling wind, winters around the mountain had always been quiet. The main lodge at the mountain had burned to the ground in 1931, and the Mount Baker Highway always closed for the season when the first snows fell, shutting off motorized access. But the winter of 1934–1935 was different. Hollywood director William Wellman was filming Jack London's classic story *The Call of the Wild*, and he needed a location that would be believable as the Yukon Territory. Mount Baker, despite—and because of—its access issues, was perfect. The crew arrived just before Christmas, and the Annex, which had been closed since Labor Day, was reopened to accommodate them. From the outset, there was friction between Wellman and star Clark Gable (shown here). But Gable and costar Loretta Young got along famously. In fact, Young would have Gable's baby the following year! (Courtesy of the Galen Biery Collection.)

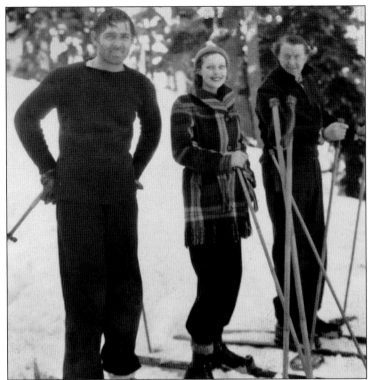

While filming *The Call of the Wild*, an epic storm blew in. The snow piled up in heroic drifts, burying equipment and sets. The road was closed by 12 feet of snow, stranding (pictured from left to right) Gable, Loretta Young, Reginald Owen, and the rest of the cast. A dogsled from the production was used to bring in provisions. (Courtesy of the Galen Biery Collection.)

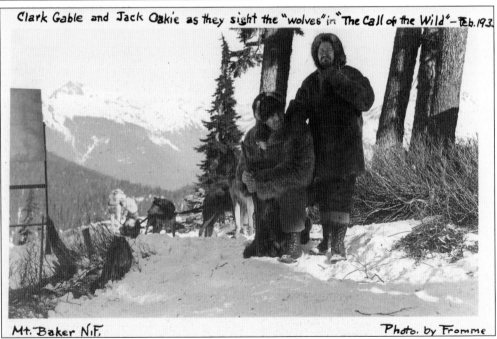

Clark Gable and Jack Oakie as they sight the "wolves" in "The Call of the Wild" – Feb. 193.

Mt. Baker N.F. Photo. by Fromme

The filming of *The Call of the Wild* was plagued by problems due to the stormy winter weather. A power outage at the lodge made for cold and unhappy actors, some of whom became ill. Cameras froze, adding to an already tense situation. (Courtesy of the National Archive Records Administration.)

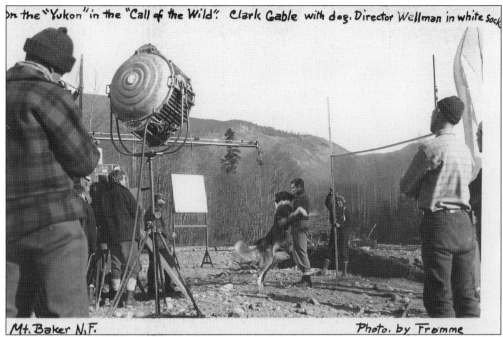

On the "Yukon" in the "Call of the Wild": Clark Gable with dog. Director Wellman in white socks

Mt. Baker N.F. Photo. by Fromme

This scene featuring Gable was shot down the mountain on the banks of the Nooksack River. The production provided a badly needed infusion of funds to the struggling Mount Baker Development Company. Twentieth Century Pictures paid the company $5,000 for the right to film at the mountain. (Courtesy of the National Archive Records Administration.)

The *Seattle Sunday Times* ran this photographic spread about *The Call of the Wild* on February 8, 1935. Filming was completed in March, and the cast and crew quickly headed back to the warmth of California. The film premiered on August 9 and proved to be a sensation. (Courtesy of the Galen Biery Collection.)

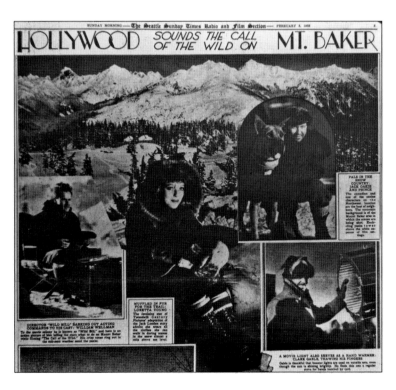

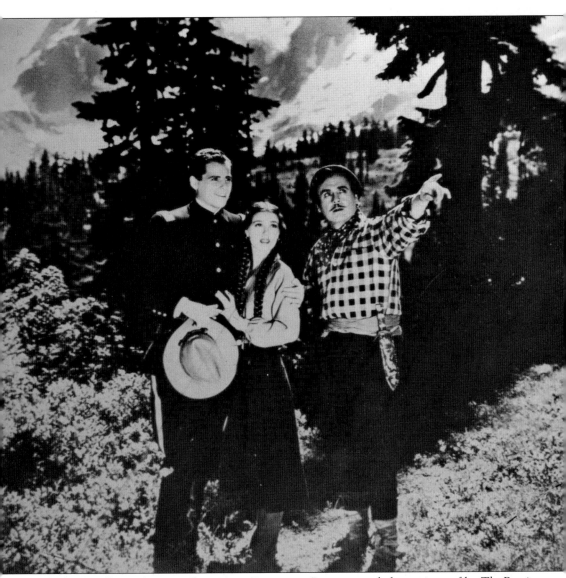

In 1937, Hollywood came calling again. Paramount Pictures needed a setting to film *The Barrier*, based on Rex Beach's 1908 novel set in the Yukon during the Alaska gold rush. The story, heavily influenced by the work of Jack London, tells the tale of Necia, a young girl menaced by her murderous father. Necia finds her protector in the handsome Lieutenant Burrell and—surprise!—all ends well. It was a classic tale of the north, with danger, intrigue, and romance in equal portions. An earlier, silent version of *The Barrier* had been filmed in 1917, but the 1937 production pulled out all the stops. Director Lesley Selander (of Hopalong Cassidy fame) was just becoming established, and he insisted on an authentic look to the production. Stars Jean Parker (center), James Ellison (left), and Leo Carrillo are seen here with Mount Shuksan in the background. (Courtesy of the Galen Biery Collection.)

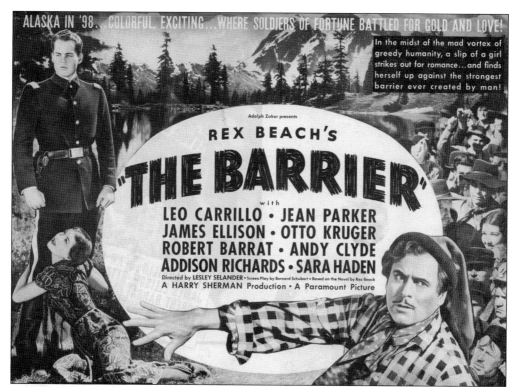

Capitalizing on the interest in northern adventure tales, *The Barrier* promised a "mad vortex of greedy humanity." Workers arrived at Heather Meadows on June 17, 1937, and immediately began to create the Yukon Territories village of Flambeau. By July, cast and crew had arrived. (Courtesy of Todd Warger.)

More than 50 log cabins were constructed in Heather Meadows for *The Barrier*. Washington's governor, Clarence D. Martin, and Bellingham mayor W.P. Brown presided over an official welcoming ceremony. Governor Martin had negotiated a deal with Paramount to hire unemployed locals as extras. They were paid $60 per week. (Courtesy of Margaret Hellyer.)

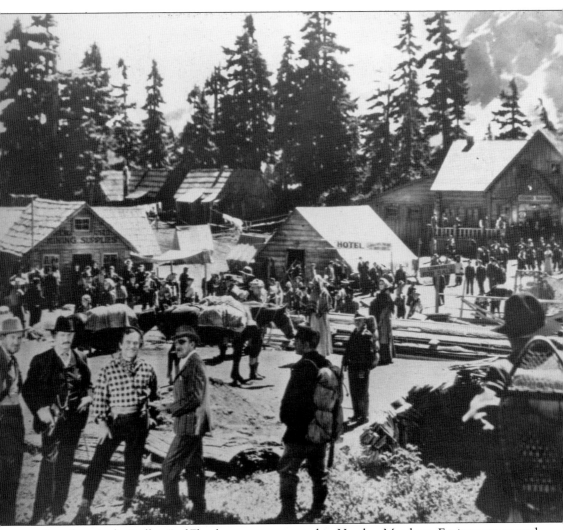

Seen here is the "village" of Flambeau, reconstructed in Heather Meadows. Excitement around the filming ran high. Governor Martin reportedly wanted to be in the movie (and get up close and personal with star Jean Parker). According to the *Spokane Spokesman Review*, he eagerly went into a lake that was part of the set, "wading in with his whole summer outfit on, pulled her out of the water and kissed her." The production offered much-needed employment at a time when jobs in the Mount Baker region were scarce. To portray soldiers in the movie, 60 ex-soldiers from the American Legion were hired, adding to the economic benefit that the production brought to the area. Paramount spent $30,000 per day on the filming and benefited from the authenticity of the set location and the low-cost labor provided by locals. (Courtesy of the Galen Biery Collection.)

Unlike *The Call of the Wild*, *The Barrier* was filmed in midsummer and attracted lots of curious locals who came to Heather Meadows to get a glimpse of the movie stars and share in the excitement. A total of 20,000 people visited the mountain in June and July. (Courtesy of Margaret Hellyer.)

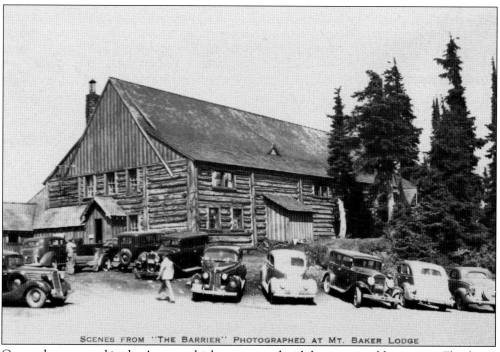

Cast and crew stayed in the Annex, which was covered with logs to resemble a store in Flambeau. The Heather Inn was converted into a dance hall/saloon. Shooting was completed on July 28; shortly thereafter, Heather Meadows returned to its original appearance. (Courtesy of Wes Gannaway.)

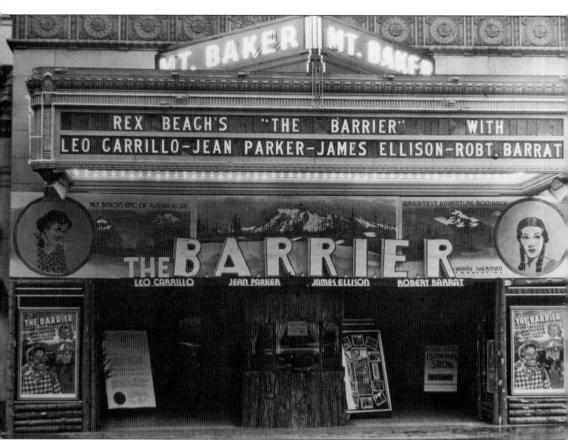

The Barrier opened in November 1937 and was well received. It played at the Mount Baker Theatre in Bellingham to enthusiastic audiences that included many local people who had been involved as extras. Mount Baker had become established as a setting to replicate Alaska and the Yukon in the sweeping adventure epics of the day, but interest in these stories was waning. Ironically, an effort to construct ski lifts at Heather Meadows had been met with opposition from the Forest Service in 1936 due to the impact that this development would have on the fragile subalpine meadows. Apparently, the construction of a "village" was deemed acceptable, largely due to the influx of Hollywood cash. The economic benefit was short-lived, however. By 1941, the Mount Baker Development Company was bankrupt, and the lodge was sold at auction. (Courtesy of the Galen Biery Collection.)

Seven

Boots on the Mountain

As the 20th century dawned, a new era of recreation was ushered in on Mount Baker. Although the major summits had been surmounted, new routes were established, and the opportunities to test one's mettle on the slopes were plentiful. A new breed of visitor began to be attracted to the mountain, drawn by both the challenge of the heights and the sheer joy of cutting steps in the snow. The climbing and hiking clubs that had sprung up made tramping on the mountain a social experience, and there was no shortage of opportunities to discover the pleasures of what was becoming a vast recreational playground. In addition to climbers, increasing numbers of hikers came to Mount Baker, content to ramble through the woods and flower-filled alpine meadows below the ice in search of both solitude and camaraderie. Thanks to the construction of new roads, access was improving, and the days of long, torturous approaches were fading into memory. The wagon road to Maple Falls was extended to Boulder Creek, near the town of Glacier, in 1893. Beyond that, an improved trail known as the Cascade State Trail reached the banks of Ruth Creek. The Mount Baker Highway was begun in 1921, affording easy access to Austin Pass. The construction of the Mount Baker Lodge was underway by 1923, and when the lodge opened in 1927, Mount Baker had become a destination for even casual tourists. Alpenstocks in hand, these happy wanderers discovered the myriad delights of alpine country that was without equal in the Pacific Northwest.

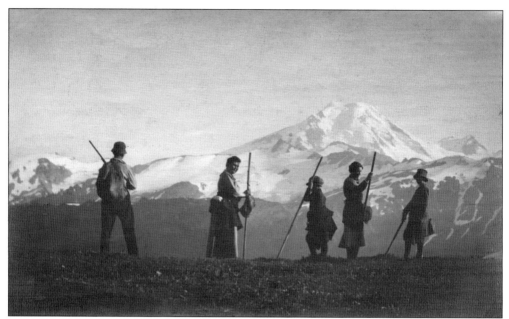

A summer outing on Skyline Divide afforded this group of hikers a spectacular view of Mount Baker in 1914. Pictured from left to right are Henry Engberg (president of the Mount Baker Club), Frances Larrabee (wife of Fairhaven cofounder C.X. Larrabee), her son Ben, Mrs. James Prentice, and an unidentified woman. (Courtesy of Gordy Tweit.)

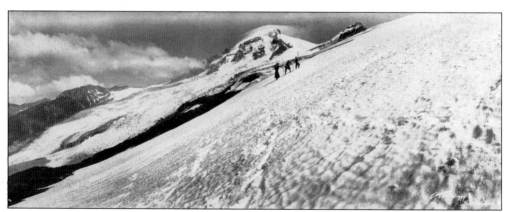

Climbers approach the summit of Mount Baker on the Roosevelt Glacier. The Roosevelt is one of 10 main glaciers that encircle the mountain. The glaciers have presented formidable obstacles to climbers since the first ascent by Edmund T. Coleman in 1868. (Courtesy of Gordy Tweit.)

IN
MEMORY OF
JULIUS·DORNBLUT
VENE·FISHER
MAYNARD·HOWAT
ALICE·JAMES
BEULAH·LINDBERG
HOPE·WEITMAN
MOUNT BAKER
JULY·22·1939·
YOU WILL BE FOREVER
CLIMBING UPWARD NOW·

Recreation on the mountain was not without its risks. On July 22, 1939, an avalanche swept down on a climbing party from the Western Washington College of Education, killing three young men and three young women. Mountain guides Fred Gleason and Robert H. Hayes, leading a 28-member search party based at Kulshan Cabin, suggested that the shouting of the 25 young climbers may have triggered the avalanche. At the time, it was very hot on the mountain, with temperatures above 90 degrees. The avalanche struck when the climbers were a scant 400 feet below the summit. According to Genevieve Strain, one of the survivors, "I definitely did what I'd been told. I dug in with my alpenstock and hung on for dear life while I slid about 500 feet." It was the worst accident in the mountain's history. (Courtesy of the Galen Biery Collection.)

Over the years, climbing accidents have claimed numerous lives on Mount Baker. J.C. Bishop (right), the president of the British Columbia Mountaineering Club, fell to his death near the summit in 1913. Although he was an experienced climber, Bishop reportedly stepped backward into a crevasse while taking a photograph. (Courtesy of John C. Miles.)

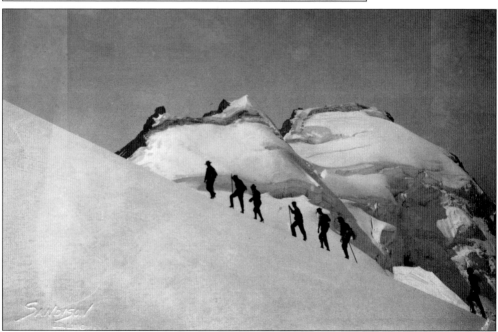

Climbers pass the Black Buttes—Colfax and Lincoln Peaks—on their way to the top of Mount Baker. These peaks were named by Edmund T. Coleman, the first to reach the summit. He named the high point of the mountain Grant Peak after Ulysses S. Grant. Schulyer Colfax was Grant's vice president. (Courtesy of Gordy Tweit.)

The Mazamas Mountaineering Club played a major role in opening Mount Baker to recreational use. The group, based in Portland, Oregon, was founded in 1894 and became active on Mount Baker the very next year. They reached the summit in 1906 via a route up the northeast side of the mountain. Leading this group, dubbed "the six immortals," was F.H. Kiser. (Courtesy of John C. Miles.)

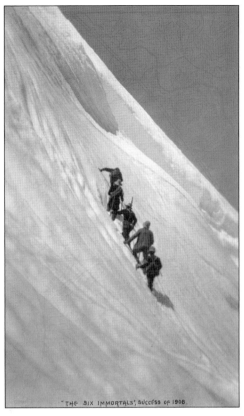

"THE SIX IMMORTALS", SUCCESS OF 1906.

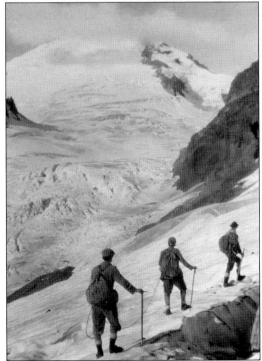

The Mount Baker Club, based in Bellingham, was founded in 1911 as a business organization. Over the years, the club dedicated itself to promoting the recreational opportunities on the mountain. It advocated for the creation of a Mount Baker National Park in 1916. (Courtesy of the Galen Biery Collection.)

In 1911, the Mount Baker Club built this cabin on Ridley Creek on the south side of the mountain in what would become known as Mazama Park. It provided accommodations for climbers and hikers and was utilized during the Mount Baker Marathon. (Courtesy of Margaret Hellyer.)

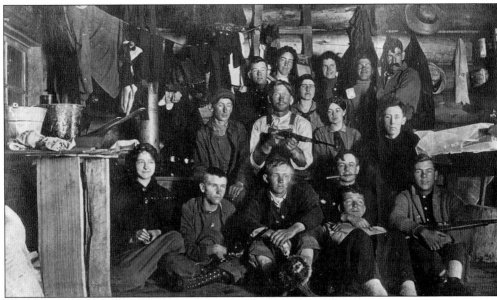

A group of alpine adventurers pose inside the Mazama Cabin. In 1925, the Mount Baker Club constructed a second cabin on the mountain for the use of climbers and hikers, beside Grouse Creek near Heliotrope Ridge. The cabin was eventually torn down and removed by the US Forest Service in the 1980s. (Courtesy of Margaret Hellyer.)

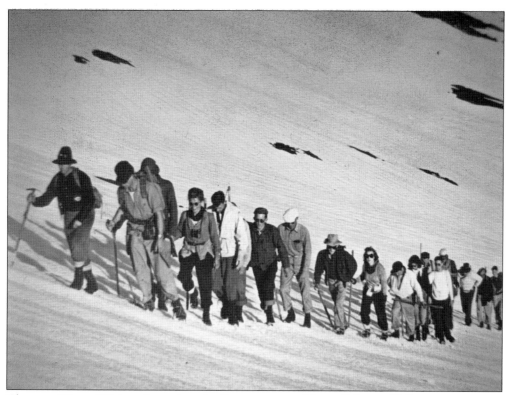

Clarence "Happy" Fisher, shown here leading a group up Mount Baker in 1942, was a mountain guide for decades. Fisher was a schoolteacher by profession, but his passion was the mountains of the North Cascades. He was the first to reach the summit of 9,443-foot Colfax Peak. (Courtesy of the Galen Biery Collection.)

The lower slopes of Mount Baker were famous for dense forest and nearly impenetrable brush. Trails were developed to spare climbers and hikers the necessity of fighting their way through tangles of devil's club and stinging nettles. The Glacier Trail, pictured here, was a major route to tree line. (Courtesy of the Galen Biery Collection.)

In addition to mountaineering and hiking, the mountain was extensively used by hunters. As access improved due to new roads and improved trails, the number of hunters increased. They stalked mountain goat, bear, elk, deer, ptarmigan, grouse, and, occasionally, as seen here, even marmots. (Courtesy of Margaret Hellyer.)

Crossing the area's many streams could be challenging, especially in the early summer, when they were swollen with melted snow. Over the years, bridges were constructed over some of these raging torrents. In many cases, however, they were promptly swept away. (Courtesy of the Galen Biery Collection.)

Eight

SKIS, SNOWBOARDS, AND DUCT TAPE

The first skiers at Mount Baker were hearty souls indeed. In 1929, the snows of Heather Meadows were tracked by skis for the first time by members of the Mount Baker Club. Founded in 1911 by Whatcom County civic leaders and businessmen, the club was the driving force behind the short-lived Mount Baker Marathon (precursor to the modern-day Ski to Sea race) and quickly established itself as the primary promoter of all things recreational in the Mount Baker area. That first ski outing in January 1929 was a grueling affair, requiring an 11-mile hike. Heavy eight-foot-long, homemade wooden skis had to be carried from the village of Glacier to Heather Meadows. From there, the intrepid sportsmen climbed the slopes with their skis, strapped them on, and enjoyed the short ride down. Broom handles served as ski poles. In the absence of ski lifts, a day on the slopes was a strenuous undertaking.

In the winter of 1934–1935, the Mount Baker Highway was kept open (mostly) all winter to accommodate the filming of *The Call of the Wild* on the mountain. For the first time, skiers could drive to the mountain, and the lodge was kept open. Mount Baker as a ski destination had arrived. Although financial issues plagued the ski area for years, gradual improvements to the infrastructure transformed it into a beloved venue for snow sport enthusiasts.

Since 1968, the Mount Baker Ski Area has been run by the Howat family. Under their guidance, the resort has become a snowboarding mecca. Operations manager Gwyn Howat explains the area's resurgent popularity: "There are just some places on Earth where magic combinations of natural elements come together and create special conditions for a particular sport. Baker just happens to be one of those places for those who enjoy snow." Its popularity continues to grow as new generations of skiers and snowboarders flock to the mountain each winter for thrills, excitement, and some of the most beautiful mountain scenery on Earth.

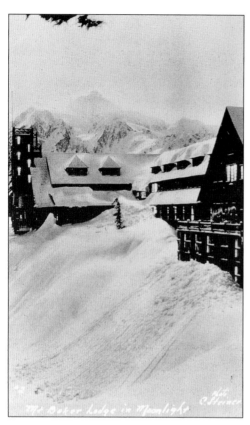

This photograph, taken before the lodge was destroyed by fire in 1931, shows the extent of the midwinter snowpack in moonlit Heather Meadows. The all-time world record for snowfall in a season was set here in 1988–1989, when 1,140 inches (95 feet) fell. (Courtesy of Margaret Hellyer.)

In addition to skiing, other winter sports attracted snow lovers to Mount Baker. Traveling on snowshoes enabled visitors to experience the silence and tranquility of the season at Heather Meadows. Snowshoers roamed the countryside through deep powder, visiting Artist Point, the Bagley Lakes, and Table Mountain. (Courtesy of the Galen Biery Collection.)

In 1935, the Mount Baker Ski Area introduced a "ski escalator" to transport skiers up the slopes. Essentially a massive wooden sled attached to a "steam donkey" (a steam-powered winch used in logging operations), the ski escalator was operated by its inventor, Arthur Brandlund, a local logger. It hauled up to 30 passengers at a time from Terminal Lake to the top of Panorama Dome, a vertical rise of 900 feet. Brandlund received permission from the Forest Service to charge 25¢ per person for the service. It was the first conveyance of its type in the Pacific Northwest. Unfortunately, less than a month after its introduction, an avalanche swept down on Brandlund as he was preparing the escalator for a day of hauling. He was killed instantly, and the ski escalator was replaced by a rope tow. (Courtesy of the Whatcom Museum.)

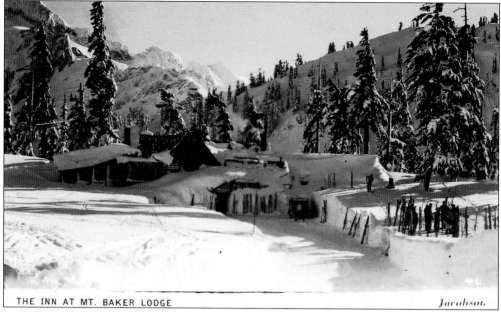

THE INN AT MT. BAKER LODGE *Jacobson*

By 1938, the ski area was attracting skiers from around the region. The Northwest Ski Association organized downhill and slalom events at the mountain. Oil-fired heaters had been installed in the Annex, now managed by Bert Huntoon's brother-in-law Harold Scheerer. A ski patrol was started, and equipment rentals were made available for the first time. (Courtesy of Margaret Hellyer.)

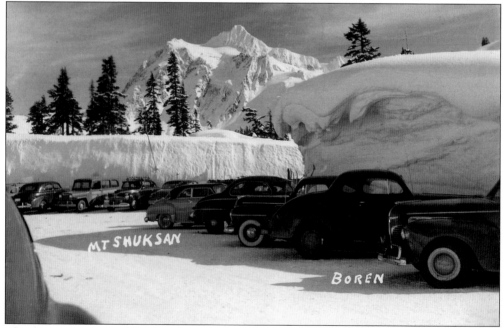

The ski area was essentially shut down during World War II, when gasoline shortages precluded plowing the Mount Baker Highway in winter, spelling the end for the Mount Baker Development Company. Ownership changed hands several times. In 1952, the Mount Baker Recreation Company was formed, and the winter of 1953–1954 saw 25,000 skiers on the mountain. The first ski lift began operation in 1954. (Courtesy of Margaret Hellyer.)

106

The Mount Baker Slush Cup had its origins in the late 1940s, when the Koma Kulshan Ski Club organized a July Fourth giant slalom race. It was promoted as the only ski tournament in the United States to be held in July. Skiers would race down a slope and attempt to be carried across a snowmelt pool by their momentum. (Courtesy of Sarah Gabl.)

The Mount Baker Recreation Company prospered during the 1950s and 1960s. A second chairlift was constructed in 1965, and a third the following year. The two new lifts increased the resort's lifting capacity from 1,900 skiers per hour to 5,000. In 1971, a new day lodge opened. (Courtesy of Sarah Gabl.)

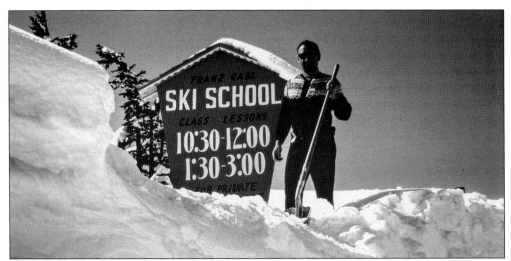

Austrian-born skier Franz Gabl was an important figure in the development of the ski area. Gabl, an Olympic medalist, opened his Ski School at the Mount Baker Ski Area in the 1960s. He was an enthusiastic promoter of the Mount Baker area and was instrumental in starting the Ski to Sea race in 1973, based on the legendary Mount Baker Marathon. (Courtesy of Sarah Gabl.)

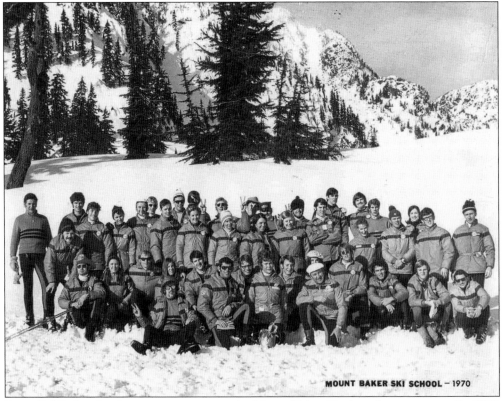

Franz Gabl's ski school was an institution at the Mount Baker Ski Area for many years. By 1969, there were 36 instructors giving lessons on the mountain, and more than 800 skiers were enrolled in programs organized by Gabl (far left). Here, he poses with eager students in 1970. (Courtesy of Sarah Gabl.)

During the 1980s, Mount Baker was one of the first ski areas in the United States to welcome snowboarders, after ski area manager Duncan Howat gave boarding a try and liked it. Pioneers in the sport, like Tom Sims, Craig Kelly, and Mike Olsen, were regular visitors to the mountain. The Legendary Banked Slalom had its debut at the ski area in 1985. Today, it is the longest continuously running snowboard competition in the world. Instead of prize money, the winner receives a "duct tape" trophy. According to ski area operations manager Gwyn Howat, "the duct tape trophy is an ode to the good old days before snowboard boots when snowboarders had to duct tape their 'after ski' boots to make them stiff enough to ride in and then often duct tape themselves to their bindings so the bindings wouldn't release." (Courtesy of Mount Baker Ski Area.)

Olympic gold-medal winner Maëlle Ricker is awarded the "duct tape trophy" for winning the Legendary Banked Slalom in 2012. Ricker has won the event seven times. The competition attracts snowboarding's elite from around the globe, as well as local "shredders." (Photograph by Ryan Duclos; courtesy of Mount Baker Ski Area.)

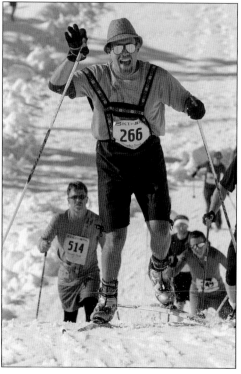

Although the Mount Baker Marathon lasted only three years, its enduring legacy helped give rise to the modern-day Ski to Sea Race, held each Memorial Day. This relay race consists of seven legs: cross-country skiing, downhill skiing or snowboarding, running, road biking, canoeing, mountain biking, and sea kayaking. The course covers nearly 100 miles, from the Mount Baker Ski Area to Fairhaven. (Courtesy of Whatcom Events.)

Nine

AROUND THE MOUNTAIN

At 10,781 feet, Mount Baker is the highest point in Northern Washington State and the third-highest peak in the state. This great ice-covered volcano is surrounded by a veritable sea of sublime peaks: the North Cascades. In the century and a half since recreation gained a foothold in Northwestern Washington, these mountains—dubbed America's Alps—have become one of North America's prime destinations for mountaineers, hikers, and alpine country sightseers. Mount Shuksan, the striking and heavily glaciated peak east of Baker, has been called the most photographed mountain in the country, and its impressive presence looming over the Mount Baker Ski Area makes this claim easy to accept. At 9,127 feet, it is the ninth-highest mountain in the state. Trails snake throughout the area, radiating from Baker and providing access to crystalline lakes, verdant alpine meadows, and awe-inspiring lookouts that have drawn recreationalists since 1906, when the venerable Mazama Club, based in Portland, Oregon, organized the first outings to Mount Baker.

Construction of the Mount Baker Highway in 1921 made exploring this epic mountain landscape an experience available to even casual sightseers. Today, tourist attractions like Artist Point, Heather Meadows, and Baker Lake draw a steady stream of visitors from around the world, eager to sample the scenic glories of the North Cascades. The Mount Baker–Snoqualmie National Forest (originally created as the Washington Forest Reserve by Pres. Grover Cleveland in 1897) encompasses much of the land around the mountain, including the massif itself. North Cascades National Park, one of the gems of the US National Park system, borders the National Forest and, together, they represent a vast public resource. Much of the national forest is a designated wilderness area. This protection, along with that of the national park, ensures that these remarkable mountain landscapes will be preserved for generations to come.

Twin Lakes, at the base of Winchester Mountain, is located in the heart of the original gold fields. This picturesque spot was reached by a primitive trail up Swamp Creek. Today, a rough road climbs 1,000 feet in a mile to reach the lakes, a popular camping spot. (Courtesy of the Galen Biery Collection.)

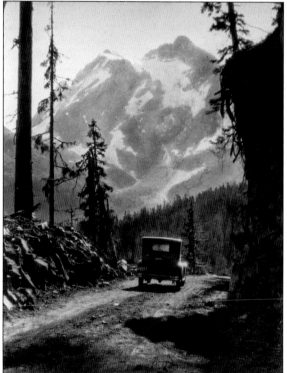

The Mount Baker Highway, built in 1921, provides access to the mountain from the population centers to the west. Originally a seasonal road, the highway was first kept open in winter to accommodate the filming of *The Call of the Wild* at Heather Meadows in 1934. (Courtesy of the Galen Biery Collection.)

The Mount Baker Highway reaches its terminus at aptly named Artist Point. The three-mile stretch of road from Heather Meadows to Artist Point was completed in 1931. To this day, the road is open for only a few months each summer, due to lingering snowpack. (Courtesy of the Galen Biery Collection.)

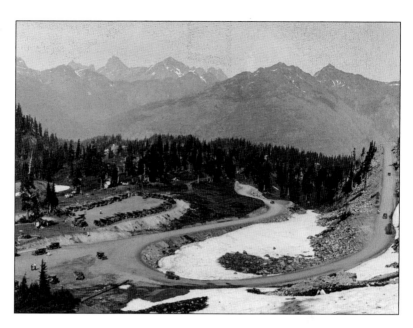

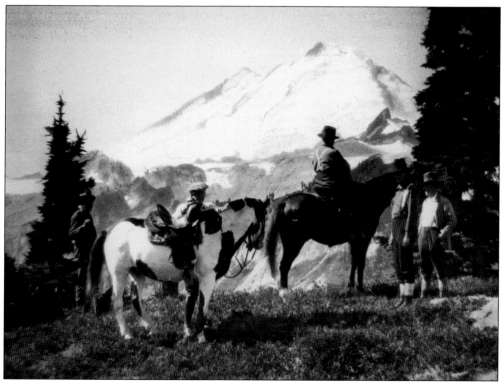

Artist Point has been a scenic destination since the 1920s, when access was possible only on foot or horseback. The point, situated on Kulshan Ridge, was a favorite destination for guests at the Mount Baker Lodge. The highest spot on the ridge is Huntoon Point, named for Bert Huntoon. (Courtesy of the Galen Biery Collection.)

Immediately east of Mount Baker, Mount Shuksan's towering western face is a familiar sight to people around the globe, thanks to the countless photographs of it that have appeared in calendars, posters, and advertisements. The Lummi Nation called this epic peak *šéqsan*, which translates loosely as "high peak." Rising 9,135 feet, the mountain is particularly impressive when viewed from the area around the Mount Baker Ski Area. Mount Shuksan was first summited in 1906

and remains a popular climb today. In addition to the main summit pyramid, Shuksan boasts two lesser peaks; the Nooksack Tower and the Hourglass. Heavily glaciated, Mount Shuksan's ramparts are laced with numerous waterfalls, including Sulphide Creek Falls, one of North America's tallest at more than 2,000 feet, emanating from Sulphide Lake on the mountain's southeast side. (Photograph by John D'Onofrio.)

The Bagley Lakes are nestled in a rocky basin near Heather Meadows. A small hydroelectric plant was constructed on the outlet of lower Bagley Lake in 1927 to supply electrical power to the Mount Baker Lodge. The lakes are named for Charles Bagley, who accompanied Banning Austin on his early explorations of the area. (Courtesy of the Galen Biery Collection.)

Baker Lake, located south of Mount Baker, is a natural body of water that was enlarged by the construction of the Upper Baker Dam in 1959, which raised the water level by more than 300 feet. Today, the lake is a popular recreational destination for boaters, fishermen, and campers. (Photograph by John D'Onofrio.)

Mount Baker is less than 35 miles from the salt water of the Strait of Georgia, and it is this proximity that accounts for the prodigious snowpack that the mountain receives each winter. This view captures the juxtaposition of the Patos Island Lighthouse, built in 1893 to aid navigation in the San Juan Islands, with the towering mountain, a dominant presence throughout the archipelago. (Photograph by John D'Onofrio.)

Nooksack Falls have long been both a scenic wonder and a source of power in the Mount Baker region. During the Mount Baker Gold Rush, a mining claim here was revealed to be a surreptitious hydroelectric project. The falls drop 88 feet in a thunderous roar that shakes the ground at high flow. (Courtesy of the Galen Biery Collection.)

117

North Cascades National Park was created by Pres. Lyndon B. Johnson in 1968. The park, which adjoins the Mount Baker–Snoqualmie National Forest, includes 684,237 acres of pristine alpine wilderness and densely forested river valleys. The park had its origins in the Whatcom Primitive Area, created in 1931. A study team created by Pres. Franklin D. Roosevelt in 1937 determined that the area would "outrank in its scenic, recreational and wildlife values any existing national park and any other possibility for such a park in the United States." The promotion of the area as a national park was championed by Washington senator Henry "Scoop" Jackson, a tireless advocate for preservation. Today, the national park includes dozens of major peaks, more than 300 glaciers, 127 alpine lakes, and nearly 400 miles of trails. Combined with surrounding public lands, more than two million acres of wilderness are preserved for future generations. (Photograph by John D'Onofrio.)

The Twin Sisters Range rises to the west of Mount Baker. The South Twin, at 7,000 feet, is the high point of this compact range, which is geologically distinct from the North Cascades. The South Twin was first climbed by J.M. Edson (left), E.A. Hegg, and P.J. Parris (right) in 1891. (Courtesy of the Galen Biery Collection.)

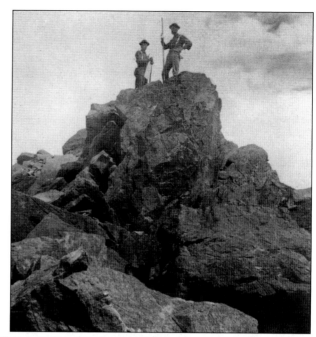

To the north of Mount Baker, a row of jagged peaks lines the international border. Mount Larrabee (right) was the center of mining activity during the Mount Baker Gold Rush. The Boundary Red and Gargett Mines were located high on its slopes. Today, the border peaks are a popular hiking area. (Photograph by John D'Onofrio.)

In this World War II–era photograph, bombers from McChord Field pass over Mount Baker. In 1994, a hiker stumbled upon the wreckage of a Navy P-38 fighter plane that had crashed on the mountain in 1942. During the war, Navy planes flew combat missions and antisubmarine missions along the West Coast in response to concerns about a Japanese invasion. The plane, piloted by Lt. Kenneth W. Ambrose, was part of a squadron based at Naval Air Station Whidbey and was carrying a crew of five. It went missing on November 28, 1942. An extensive search, hampered by bad weather in the mountains, was unsuccessful in locating the missing aircraft. The downed plane, buried for 50 years by snow and glacial ice at the 7,500-foot level on the peak, became visible as the glacier receded in recent years. (Courtesy of Margaret Hellyer.)

Table Mountain rises above Artist Point. Its broad summit affords an unobstructed view of both Mount Baker and Mount Shuksan. Named for its flat top, Table Mountain has been a popular vantage point since the days of the Mount Baker Lodge. (Courtesy of the Galen Biery Collection.)

The Park Butte Lookout is typical of the fire lookouts in the Mount Baker–Snoqualmie National Forest. Built in 1932 at the heyday of lookout construction, the structure, like many others scattered around the North Cascades, was originally utilized to spot forest fires, a duty long ago relegated to airplanes. (Photograph by John D'Onofrio.)

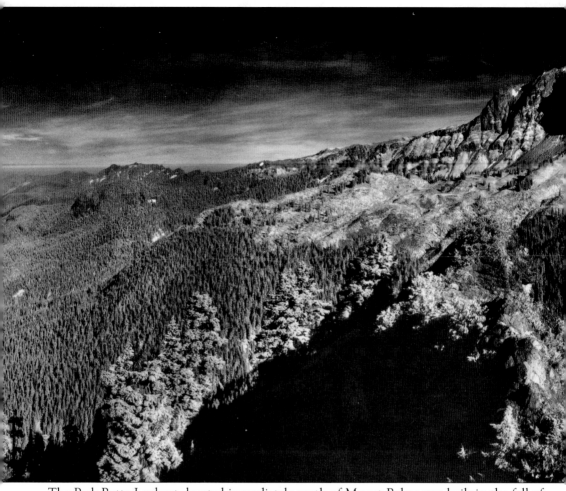

The Park Butte Lookout, located immediately south of Mount Baker, was built in the fall of 1932 and was used for fire detection until 1961. In 1962, the Skagit Alpine Club volunteered to maintain the structure, saving it from destruction. Thanks to their volunteer efforts, led by Fred T. Darvil, the lookout remains in good condition to this day and is available for overnight use. Many of the lookouts were constructed by the Civilian Conservation Corps (CCC), formed by

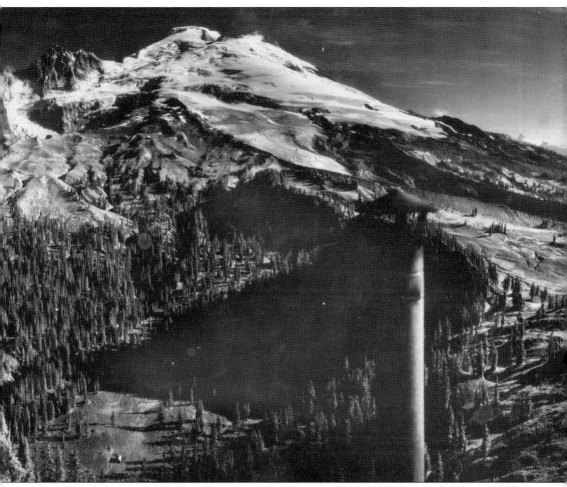

Pres. Franklin D. Roosevelt during the Depression. Several of the lookouts in the North Cascades gained fame as the haunts of poets and writers, including Jack Kerouac, Gary Snyder, and Philip Whalen. Kerouac's stay in the lookout on nearby Desolation Peak in 1956 figures prominently in his books *Desolation Angels* and *The Dharma Bums*. This photograph was taken in September 1935 from the roof of the lookout. (Courtesy of John Scurlock.)

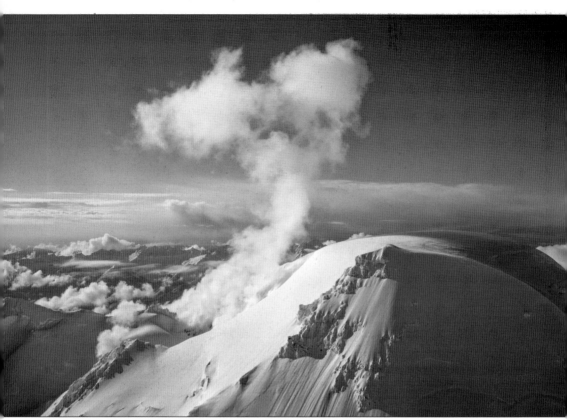

After Mount Saint Helens, Mount Baker is the most active of the Cascade volcanoes. Geologically speaking, Mount Baker is young, perhaps no more than 100,000 years old. Volcanic activity was centered at the ancient Kulshan Caldera, which exploded in a gargantuan eruption more than a million years ago. Today, volcanic activity is focused in the Sherman Crater, 1,000 feet below the summit, as well as at the Dorr Fumerole Field, at an elevation of 7,800 feet on the northeast side of the mountain. An eruption emitting from the Sherman Crater occurred 6,600 years ago, sending ash raining down as far as 40 miles away. A lahar flow (consisting of pyroclastic materials, mud, rocks, and water) more than 300 feet high flowed into the Middle Fork of the Nooksack River. The flow was still 25 feet deep, 30 miles downstream! (Courtesy of John Scurlock.)

The mountain has remained restless. In 1792, explorer Dionisio Galiano reported strange fires in the sky while he was anchored in Bellingham Bay. According to his report, "During the night we constantly saw light to the south and east of the mountain of Carmelo [Baker] and even at times some bursts of flame, signs which left no doubt that there are volcanoes with strong eruptions in those mountains." (Courtesy of John Scurlock.)

The years 1975 and 1976 saw periods of increasing activity in the Sherman Crater, and temperatures there increased tenfold. As a precaution, public access was restricted, and water levels in Baker Lake and Lake Shannon were drawn down to protect against inflows of lahars. This activity stimulated increased monitoring of the volcano. Here, Dave Tucker, director of Bellingham's Mount Baker Volcano Research Center, measures volcanic activity. (Courtesy of John Scurlock.)

The administrative center for the National Forest lands around Mount Baker is the Glacier Public Information Center, located in the town of Glacier. The building was constructed of native materials in 1938 by the Civilian Conservation Corps. (Photograph by John D'Onofrio.)

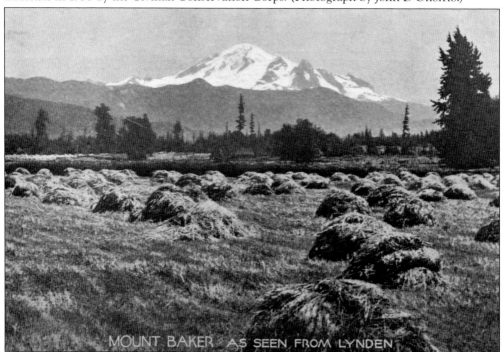

Mount Baker dominates the landscape throughout Northwest Washington. This view of the mountain from the town of Lynden reveals the great volcano's majestic character and powerful presence. For everyone, from the native people who lived here thousands of years ago, to the modern inhabitants of Western Washington, Mount Baker is an iconic symbol of nature's glory. (Courtesy of Gordy Tweit.)

BIBLIOGRAPHY

Beckey, Fred. *Range of Glaciers: The Exploration and Survey of the Northern Cascade Range.* Portland: Oregon Historical Society Press, 2003.

Easton, Charles Finley. *Mt. Baker, Its Trails and Legends.* Bellingham, WA: Whatcom Museum. Unpublished scrapbook, compiled 1903–1940.

Gannaway, Wesley and Kent Holsather. *Whatcom: Then and Now.* Bellingham, WA: LoneJack Mountain Press, 2004.

Hazard, Joseph T. *Snow Sentinels of the Pacific Northwest.* Seattle: Lowman & Hanford Company, 1932.

Heller, Ramon. *Mount Baker Ski Area: A Pictorial History.* Bellingham, WA: Mount Baker Recreational Company, 1980.

Impero, Michael G. *The Lone Jack: King of the Mount Baker Mining District.* Bellingham, WA: Self-published, 2007.

———. *Dreams of Gold: History of the Mount Baker Mining District.* Bellingham, WA: Self-published, 2010.

Jacoby, Laura. *Reflections from the Heart of a Small Community: Mount Baker Foothills and Maple Falls Schools 1889–1999.* Maple Falls, WA: Maple Falls Memory Book Committee, 1999.

Majors, Harry M., ed. *Mount Baker: A Chronicle of its Historic Eruptions and First Ascent.* Seattle: Northwest Press, 1978.

Miles, John C. *Koma Kulshan: The Story of Mt. Baker.* Seattle: The Mountaineers, 1984.

Roe, JoeAnn. *The North Cascades.* Seattle: Madrona Publishers, 1980.

Roth, Lottie Roeder. *History of Whatcom County, Washington.* Seattle: Pioneer Historical Printing Company, 1926.

Steel, W.G. *Ascent of Mt. Baker.* Portland, OR: Mazamas Steel Points, Vol. 1, No. 1, 1919.

Todd, Frances B. *The Trail Through the Woods: History of Western Whatcom County.* Baltimore: Gateway Press, Inc. 1982.

Wing, Robert C. *Joseph Baker: Lieutenant on the Vancouver Expedition.* Seattle: Gray Beard Publishing, 1992.

DISCOVER THOUSANDS OF LOCAL HISTORY BOOKS FEATURING MILLIONS OF VINTAGE IMAGES

Arcadia Publishing, the leading local history publisher in the United States, is committed to making history accessible and meaningful through publishing books that celebrate and preserve the heritage of America's people and places.

Find more books like this at
www.arcadiapublishing.com

Search for your hometown history, your old stomping grounds, and even your favorite sports team.